IMAGES
of Rail

WASHINGTON & OLD DOMINION RAILROAD

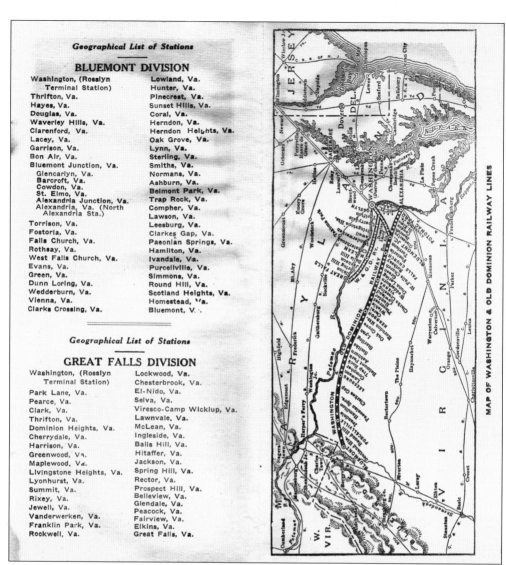

Geographical List of Stations

BLUEMONT DIVISION

Washington, (Rosslyn Terminal Station)
Thrifton, Va.
Hayes, Va.
Douglas, Va.
Waverley Hills, Va.
Clarenford, Va.
Lacey, Va.
Garrison, Va.
Bon Air, Va.
Bluemont Junction, Va.
 Glencarlyn, Va.
 Barcroft, Va.
 Cowdon, Va.
 St. Elmo, Va.
 Alexandria Junction, Va.
 Alexandria (North Alexandria Sta.)
Torrison, Va.
Fostoria, Va.
Falls Church, Va.
Rothsay, Va.
West Falls Church, Va.
Evans, Va.
Green, Va.
Dunn Loring, Va.
Wedderburn, Va.
Vienna, Va.
Clarks Crossing, Va.

Lowland, Va.
Hunter, Va.
Pinecrest, Va.
Sunset Hills, Va.
Coral, Va.
Herndon, Va.
Herndon Heights, Va.
Oak Grove, Va.
Lynn, Va.
Sterling, Va.
Smiths, Va.
Normans, Va.
Ashburn, Va.
Belmont Park, Va.
Trap Rock, Va.
Compher, Va.
Lawson, Va.
Leesburg, Va.
Clarkes Gap, Va.
Paeonian Springs, Va.
Hamilton, Va.
Ivandale, Va.
Purcellville, Va.
Simmons, Va.
Round Hill, Va.
Scotland Heights, Va.
Homestead, Va.
Bluemont, V.

Geographical List of Stations

GREAT FALLS DIVISION

Washington, (Rosslyn Terminal Station)
Park Lane, Va.
Pearce, Va.
Clark, Va.
Thrifton, Va.
Dominion Heights, Va.
Cherrydale, Va.
Harrison, Va.
Greenwood, Va.
Maplewood, Va.
Livingstone Heights, Va.
Lyonhurst, Va.
Summit, Va.
Rixey, Va.
Jewell, Va.
Vanderwerken, Va.
Franklin Park, Va.
Rockwell, Va.

Lockwood, Va.
Chesterbrook, Va.
El-Nido, Va.
Selva, Va.
Viresco-Camp Wicklup, Va.
Lawnvale, Va.
McLean, Va.
Ingleside, Va.
Balls Hill, Va.
Hitaffer, Va.
Jackson, Va.
Spring Hill, Va.
Rector, Va.
Prospect Hill, Va.
Belleview, Va.
Glendale, Va.
Peacock, Va.
Fairview, Va.
Elkins, Va.
Great Falls, Va.

MAP OF WASHINGTON & OLD DOMINION RAILWAY LINES

This Washington & Old Dominion Railway timetable was released on October 21, 1920. It lists all of the stations and the map shows their locations, which shows the maximum reach of the railroad before cost-cutting measures led to abandonment of the segments of line from Bluemont to Purcellville, the Great Falls line, and eventually the Spout Run Branch. (Courtesy of Washington & Old Dominion Railway.)

ON THE COVER: Car No. 45, a gas-electric passenger car, has just pulled into Leesburg running westbound as Train No. 5 on May 30, 1951. This was the last day that conductor John W. Kelly and engineer Foster R. Ormsbee ran passenger trains. Package mail is being unloaded into the flatbed truck. Express shipments were handled out of the baggage room just behind the engine compartment. (Photograph by John F. Burns Jr.)

IMAGES
of Rail

WASHINGTON & OLD
DOMINION RAILROAD

David A. Guillaudeu
Foreword by Paul E. McCray

ARCADIA
PUBLISHING

Published by Arcadia Publishing
Charleston, South Carolina

Printed in the United States of America

Library of Congress Control Number: 2012942655

For all general information, please contact Arcadia Publishing:
Telephone 843-853-2070
Fax 843-853-0044
E-mail sales@arcadiapublishing.com
For customer service and orders:
Toll-Free 1-888-313-2665

Visit us on the Internet at www.arcadiapublishing.com

*This book is dedicated to Douglas Lee, W. Burton Barber,
and the other railroad employees who built, operated,
and maintained such a fascinating railroad.*

CONTENTS

Foreword 6

Acknowledgments 7

Introduction 8

1. Alexandria, Loudoun & Hampshire Railroad 11

2. Southern Railway 19

3. Great Falls & Old Dominion Railroad 37

4. Washington & Old Dominion Railway and Railroad 47

5. Bridges 71

6. Electrical Distribution System 87

7. Passenger Equipment 95

8. Freight Locomotives 109

9. Maintenance of Way Equipment 117

10. Shippers and Receivers 123

FOREWORD

It has been 42 years since a new book about the W&OD Railroad has been published, so railroad enthusiasts, local historians, and anyone interested in learning about their community in Northern Virginia are in for a treat. When David A. Guillaudeu set out to create Images of Rail: *Washington & Old Dominion Railroad*, he wanted to offer new stories, new information, and lots of never-before-published photographs—a goal he accomplishes with this book.

David is a unique link between the people who knew the railroad best when it was still operating and today's avid followers of the rail line's history. As a young man, he befriended a number of the W&OD Railroad's employees and knew many of the older historians of the short-distance but long-lived railroad. Through interviews and discussions with these individuals, he heard stories and little-known facts about the W&OD, which he uses to provide interest and color in his book. These folks also shared their treasured W&OD photographs with David, and many are seen here for the first time ever.

What is it about W&OD Railroad that has kept its history alive? It helps to have thousands of people a day using the line in its new incarnation as the W&OD Trail. And as the Metro tracks from the District of Columbia continue moving westward parallel to the W&OD, we are reminded of the rail line that ran from rural and suburban Northern Virginia to the city for 110 years.

What most catches our imagination about the W&OD is the uniqueness of the railroad. Never very prosperous, the W&OD often scraped by with used and homemade equipment but held on while other local lines failed. It was one of the few railroads that, throughout its history, used all of the modes of power as technology changed. It began operation using wood- and then coal-fired steam engines, changed to a quieter and cleaner electric line, and then became a diesel engine railroad as those powerful locomotives were built.

As much as people complained about the informal way the W&OD Railroad often operated, it was sorely missed when it was gone.

—Paul E. McCray

ACKNOWLEDGMENTS

Thank you, Herbert H. Harwood for introducing me to the Washington & Old Dominion Railroad and allowing me to use some of your photographs. Thank you, Paul E. McCray for nurturing the development of the Northern Virginia Regional Park Authority's Washington & Old Dominion Railroad Regional Park as its park manager, for establishing the park authority's railroad artifact collection, and for making photographs from the collection available.

Thank you, Douglas Lee, engineer and conductor; W. Burton Barber, superintendent of maintenance of way and structures; John M. McLaney, chief dispatcher; Roger Fox, track section foreman; Charles Houchins, track section foreman; Martin and Louisa Bicksler, station agents; Eugene Bicksler, expressman; and Mark Hankins, Chesapeake & Ohio Railway real estate manager, for sharing your memories with me.

Thank you, Maria Weyraugh, the daughter of Joseph R. Weyraugh, for making your father's many photographs available and for your encouragement and participation in keeping the memories alive. Thank you, Chris Brannigan for your assistance in scanning many negatives for use in this book. Thank you, John F. Burns Jr., Gerald F. Cunningham, Leonard W. Rice, and James E. Chapman for passing on portions of your collections. Thank you, LeRoy O. King Jr. for allowing me to use yours and your father's photographs. Thank you, Richard Cataldi for your research assistance and editorial reviews. Thank you, Tracy J. Gillespie, the Aldie Mill Historic Site supervisor, for making the Northern Virginia Regional Park Authority archives available. Thank you, William Sasher and Russell Orrison Sr. for sharing your trackside memories. Thank you, Leland S. Ness for providing copies of the Russell Road overpass photographs.

Thank you, Southern Railway and Chesapeake & Ohio Railway for the structure and bridge drawings. Thank you, Evans Products Company for information on the Evans Auto-Railer, and Burro Crane Incorporated for information on the Burro crane. Thank you, Smithsonian Institution Transportation Museum for maintaining the collection of Pullman Palace Car Company photographs; the Museum of Transportation, St. Louis, for preserving the gas-electric Car No. 1180; and the Illinois Railway Museum for archiving the Pullman Palace Car Company drawings.

My apologies go to any families whose names I may have misspelled. Any mistakes are solely those of the author.

Introduction

The Washington & Old Dominion Railroad was managed by eight different organizations over its lifetime, comprising a total of ten different names. The initial organization was made up of Alexandria City merchants and bankers who wanted to tap the riches of the Shenandoah River valley, later the coalfields of West Virginia, and finally make a connection with the Midwest near the Ohio River. When Virginia seceded from the United States to join the Confederacy, the Alexandria, Loudoun & Hampshire Railroad came under the control of the US Military Railroads. After the war, the railroad reverted to the original promoters. Unfortunately, the railroad's debts piled up faster than its revenues, and it was forced into bankruptcy in 1878. Three additional companies tried to make a go of the railroad before the Richmond & Danville Railroad leased the property in 1886 to strategically stop it from expanding westward. Foreclosure on the lease's mortgage in 1894 vested the lease in the new Southern Railway. The Southern Railway operated the line until 1912 and continued to own it until 1945. The final organization was the Washington & Old Dominion Railroad. Companies involved with the Bluemont Branch and the Great Falls Division are listed below.

1847	Alexandria & Harpers Ferry Railroad
1853	Alexandria, Loudoun & Hampshire Railroad
1861–1865	US Military Railroads
1870	Washington & Ohio Railroad
1882	Washington & Western Railroad
1883	Washington, Ohio & Western Railroad
1886	Richmond & Danville Railroad
1894–1945	Southern Railway
1900	Great Falls & Old Dominion Railroad
1911	Washington & Old Dominion Railway (W&OD Railway)
1936	Washington & Old Dominion Railroad (W&OD Railroad)
1956	Chesapeake & Ohio Railway (C&O)

The board of directors incorporated the Alexandria, Loudoun & Hampshire Railroad Company on March 15, 1853. Two months later, at their first annual meeting on May 24, 1853, directors passed a resolution to begin surveying and preparing cost estimates for various routes between Alexandria and the coalfields of Virginia (later West Virginia) in Hampshire County, 180 miles away. The board selected Charles P. Manning, formerly of the Baltimore & Ohio Railroad, to be the first chief engineer. Surveying of the routes began in July, and by October, Manning had reduced his choices to two routes east of the Shenandoah River: one through Keyes Gap and one through Snickers Gap. The surveys concluded that a practical route could be found within the limits of grade and curvature that Manning had established, and that a first-class railroad could

eventually be constructed that was two tracks wide and built with one track immediately from Alexandria to the Shenandoah River for an average cost per mile of $30,000, including tunnels. Manning set the limits of grade at 79.2 feet per mile climbing westward, or 1.5 percent, and 52.8 feet per mile ascending eastward, or 1 percent; and for curvature a 1,000-foot minimum radius.

The Alexandria, Loudoun & Hampshire Railroad began construction of the first 40 miles in February 1855. Grading, bridge abutments, and arches were nearly completed by September 1858. Sterling (originally called Guildford) had been reached by September 9, 1859. Construction of the stations and Alexandria's terminal facilities also began in 1859. Regular trains began running on January 16, 1860, when the track reached Ashburn, and service to Leesburg began on May 17, 1860, the day after the rails came into town.

Union troops occupied Alexandria and captured the Alexandria, Loudoun & Hampshire Railroad on May 24, 1861. The Confederate army, in one of the first attacks on Union railroads, destroyed the Alexandria, Loudoun & Hampshire Railroad's bridges at Difficult Run, Broad Run, Beaverdam Creek, Goose Creek, Sycolin Creek, and Tuscarora Creek as well as six miles of track between June and October 1861. As the line west of Vienna was never needed by the Union forces, it was never repaired by the US Military Railroads. The US Military Railroads returned the control of the Alexandria, Loudoun & Hampshire Railroad to Lewis McKenzie as agent for the Virginia Board of Public Works on August 8, 1865, making the railroad the longest Union-held railroad of the Civil War in Virginia.

The Alexandria, Loudoun & Hampshire Railroad was authorized by the State of West Virginia in 1870 to extend its line to the Ohio River. Consequently, the company changed its name to the Washington & Ohio Railroad. The railroad extended the line to Hamilton in 1871, through Purcellville in April, 1874, and into Round Hill in October, 1874. The railroad struggled to make a profit and ended up being sold at auction in Alexandria on January 31, 1882 to the Washington & Western Railroad. Another foreclosure sale (on May 9, 1883) saw a new railroad name attached to the right-of-way: the Washington, Ohio & Western Railroad.

John Pierpont Morgan, owner of the Richmond & Danville Railroad, leased the Washington, Ohio & Western Railroad on October 30, 1886, to prevent it from becoming a major competitor. Thus, Morgan brought Alexandria's hopes for prosperity through becoming a major port city to an end. After leasing the Washington, Ohio & Western Railroad, the Richmond & Danville Railroad then bought up all of the Washington, Ohio & Western Railroad's capital stock and became the sole owner.

In 1894, the Richmond & Danville Railroad became the Southern Railway. At the insistence of local citizens, the Southern Railway extended the rail line to its final terminus, Snickersville, and named the station Bluemont.

While the Southern Railway was upgrading its stations along the Bluemont Branch in the early 1900s, another group of businessmen chartered the Great Falls & Old Dominion Railroad on January 21, 1900, and began construction in 1901. Shortly afterwards, John R. McLean and Stephen B. Elkins bought the Great Falls & Old Dominion Railroad and continued building it between Washington, DC, and Great Falls, Virginia. On March 8, 1906, the railroad ran its first regular trip between Georgetown and Difficult Run (Peacock Station/Peacock Station Road); and starting on July 4, 1906, operated trains into Great Falls, where McLean and Elkins had built a recreational park.

The success of the park led the owners, who were aspiring railroad magnates, to look for ways to expand their operation. They saw the Bluemont Branch of the Southern Railway as a natural fit and leased the branch on July 1, 1912, connecting it with the Great Falls & Old Dominion Railroad via a new double-track line. The Spout Run Division started at Thrifton Junction—near present-day Lyon Village at the intersection of Lee Highway and Spout Run Parkway—and ended at Bluemont Junction, just east of where Wilson Boulevard crosses Four Mile Run. The owners created the W&OD Railway to operate the combined trackage, providing Washingtonians a slightly shorter and easier route to retreat from the summer heat and humidity to the summer resorts in Hamilton, Purcellville, Round Hill, and Bluemont.

In the Roaring Twenties, the railroad's passenger business declined as roads were paved for the first time and automobiles and buses became more popular. Loss of business led to the cessation of operations on the Great Falls Division on June 8, 1934. The railroad had never made a lot of money and most years ran in the red. The W&OD Railway swapped the right-of-way from Thrifton Junction to Great Falls to Arlington and Fairfax Counties for relief from paying overdue taxes. The roadbed is now Old Dominion Drive.

The W&OD Railway went into receivership on January 16, 1932, was reincorporated as the W&OD Railroad on November 15, 1935, and began operations on April 16, 1936. In a move to cut further costs, the railroad abandoned the last miles of the Bluemont Branch from Purcellville to Bluemont in 1939. Unfortunately, the wills of John R. McLean and Stephen B. Elkins forced their heirs to run and pay for the operating losses of the railroad. It took until 1956 for Elkins's son, titular head of the company Davis Elkins, to get a court to break the will and allow him to sell the W&OD Railroad. Once he was free to do so, the Chesapeake & Ohio Railway was contacted. With the hopes of establishing industries along the line, a light industrial park near the Cascades community of Sterling, Virginia, and the siting of a major electric power plant in northern Loudoun County, the Chesapeake & Ohio Railway bought the W&OD Railroad, though the W&OD Railroad continued to operate as an independent railroad.

Anticipating heavier rail traffic to new industries and to provide for the delivery of sand and gravel for the construction of Dulles International Airport, the Chesapeake & Ohio Railway paid for the rebuilding of bridges along the line from Alexandria up to Goose Crook and including Tuscarora Creek on the east side of Leesburg. Unfortunately, the Fairfax County government prevented rezoning of lots along the right-of-way to industrial uses, and the Potomac Electric Power Company acceded to Maryland taxpayers' and Loudoun County citizens' demands and built the Dickerson Generating Station in Maryland.

The tariff under which the Chesapeake & Ohio Railway was paid to carry stone from the Trap Rock Quarry—the railroad's only real shipping customer—was upside down: the more stone the railroad hauled, the more money it lost. The railroad petitioned the Virginia State Corporation Commission to cease hauling intrastate shipments, and the petition was granted in 1964. Meanwhile, the Virginia Department of Highways proposed construction of Interstate 66 through Arlington County using the W&OD Railroad's Spout Run Division right-of-way to alleviate traffic congestion inside the beltway. The right-of-way between Bluemont Junction and Rosslyn was abandoned on September 21, 1962, and sold to the highway department. In another bow to Northern Virginia traffic, the Virginia Department of Highways purchased the entire railroad as a cost-saving measure, as building a Shirley Highway (now Interstate 395) bridge over the railroad would have been more expensive.

One

ALEXANDRIA, LOUDOUN & HAMPSHIRE RAILROAD

This chapter focuses on the railroad's construction and destruction during its first decade of existence. Railroad construction involved heavy lifting and strong backs. In 1917, the Interstate Commerce Commission, Division of Valuation, reported that the line to Bluemont was built with scrapers and carts. The railroad ran through hilly and rolling country. Cuts and fills, in many cases, were long and deep. Quite a few cuts were through stone that required blasting. The same report states that the stone culverts, boxes, and arches were of unusually heavy construction. Arch stone was made of very fine-quality brown sandstone. Stone structures were built of blocks transported to the site from the quarry, cut by hand using squares, rulers, and string to guide the shapes, and then lifted into place using manually powered winches. Crossties were made of oak and chestnut procured locally.

During the war, Confederate forces used hand tools, fire, and horses to tear rails from the ties and bend the rails around trees—destroying the track. In one of those twists of fate, bent rails from the Alexandria, Loudoun & Hampshire Railroad were collected and brought into Alexandria where Gen. Herman Haupt, superintendent of US Military Railroads, investigated means of both tearing up enemy track and repairing destroyed Union track. General Haupt reported on October 26, 1862 that "spans of bridges, most of them 150 feet in length, in six different localities [from Difficult Run west], require to be constructed before the road [Alexandria, Loudoun & Hampshire Railroad] can be used. The reconstruction of this road beyond Difficult Creek in time for any immediate advance will be impracticable." Union forces never had a need to rebuild the railroad beyond Vienna, so the Alexandria, Loudoun & Hampshire Railroad was left with a lot of damaged track and bridges that needed to be replaced before the rails could be extended or even before the service could be resumed.

Repairing the torn-up tracks and burned bridges took precious money from the enterprise, slowed its progress, and may have been a contributing factor in its eventual demise, when it failed to reach the Shenandoah Valley, with its farm products in need of transportation, before the competing Baltimore & Ohio Railroad did.

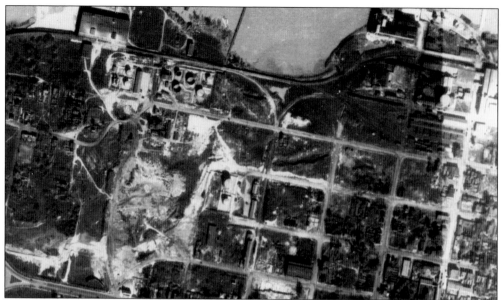

This April 30, 1937, aerial photograph shows industrial facilities along the shore of the Potomac River in Alexandria. The Alexandria, Loudoun & Hampshire Railroad's passenger station is the small, almost square building in the middle right. It is located just below the collection of small rectangles (boxcars). (Courtesy of National Archives, Record Group 114.)

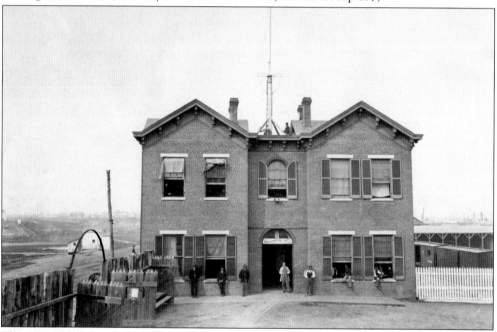

The Alexandria, Loudoun & Hampshire Railroad built its Alexandria passenger station in 1860 at the intersection of Fairfax and Princess Streets. The sign over the door reads "Quartermasters Dep't U.S. Army." Through the years, it housed the general offices of the Alexandria, Loudoun & Hampshire Railroad and its successors through the Southern Railway. The W&OD ran passenger trains to this station until 1932. (Photograph by Andrew J. Russell, courtesy of Library of Congress.)

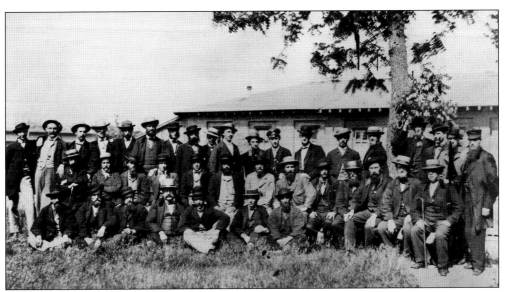

As these superintendents and conductors of the US Military Railroads worked out of Alexandria, it is probable that some of them worked the trains to Vienna. The gentleman in the middle of this 1863 picture with the full beard, dark coat, and light shirt and pants is Gen. Herman Haupt, superintendent of US Military Railroads. (Courtesy of Massachusetts Commandery, Military Order of the Loyal Legion and the US Army Military History Institute.)

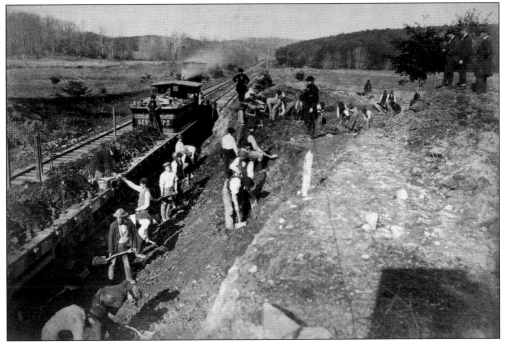

Laborers excavate the hillside for the second leg of a Y, or wye, track arrangement at Devereux Station of the Orange & Alexandria Railroad near Clifton, Virginia, in 1863. This type of effort was probably used to grade the whole line from Alexandria to Bluemont. Gen. Herman Haupt, the chief of construction and transportation, supervises in the middle of the photograph. (Courtesy of Library of Congress.)

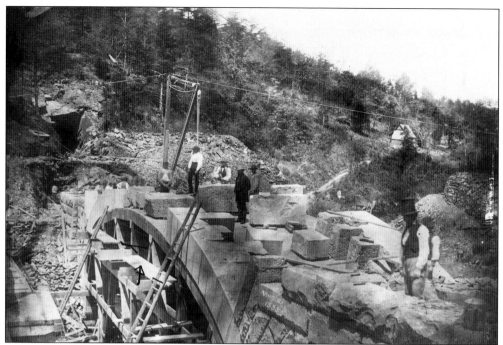

Stone-arch bridge construction required the erection of a wooden arch to support the barrel of the bridge. Shaped stones were then placed with the use of a derrick. Once the bridge was finished, the wood was removed. Here, laborers assemble Bridge No. 3 of the Washington Aqueduct on May 21, 1858. (Courtesy of National Archives.)

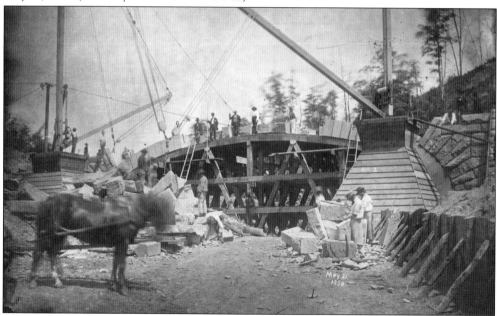

At right, stonemasons shape blocks, which will be lifted into place by either of the derricks onto Bridge No. 3 on May 21, 1858. Just above the horse's head, one stone has been chained to a derrick's blocks. This bridge is still in use today and is on the north side of MacArthur Boulevard, just west of Persimmon Tree Road in Cabin John, Maryland. (Courtesy of National Archives.)

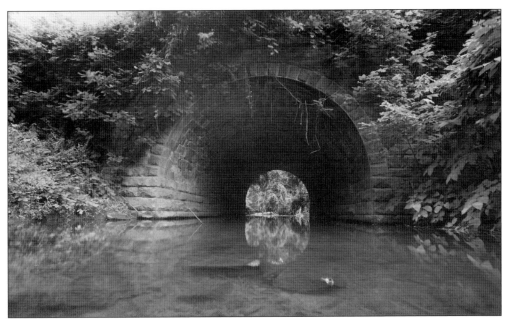

Similar techniques were probably used to build the Sugarland Run stone-arch bridge, seen here on June 27, 2012. The ledge of stone that sticks out slightly on either side of the barrel from the stone arch about three feet above the water was probably used to support the wood erection form. Sugarland Run crosses under the railroad just to the east of Herndon Parkway. (Photograph by the author.)

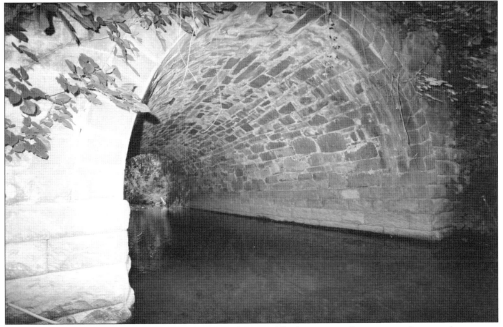

The streambed under the arch was covered with stone-block pavers to keep water from undermining the footings. Stones placed on top of the wood form are interlaced like regular brick walls. Stone drill marks can be seen at several places in this photograph, taken on June 27, 2012. (Photograph by the author.)

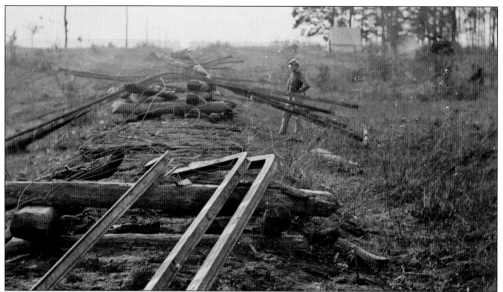

Techniques used by the Confederates to destroy the tracks of the Orange & Alexandria Railroad between Bristow Station and the Rappahannock River were captured in October 1863. General Haupt reported that Confederates softened Alexandria, Loudoun & Hampshire Railroad rails by heating them over burning ties to bend them and render them useless. (Photograph by Timothy O'Sullivan, courtesy of Library of Congress.)

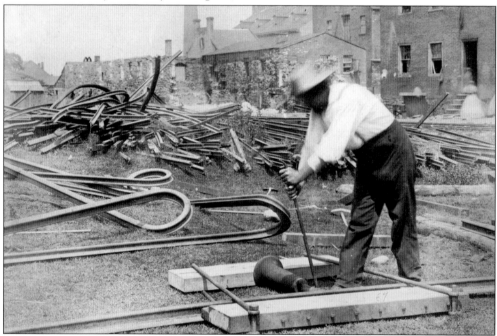

General Haupt conducted numerous experiments on ways to destroy and repair track in 1863. The iron rails in the background came from track of the Alexandria, Loudoun & Hampshire Railroad that the Confederates destroyed in the spring of 1862. General Haupt found that rails that were simply bent could be straightened with levers and sledges or with jackscrews. (Photograph by Andrew J. Russell, courtesy of National Archives.)

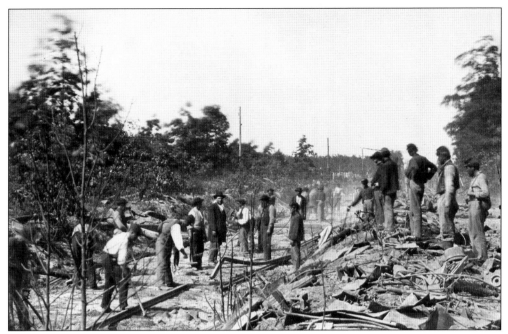

Laborers repair track of the Orange & Alexandria Railroad destroyed by the Confederates between Catlett's Station and Union Mills. Detritus from a wrecked train sits on the rise at right. The bent rail in the middle is an old-fashioned, U-shaped one. (Courtesy of Massachusetts Commandery, Military Order of the Loyal Legion and the US Army Military History Institute.)

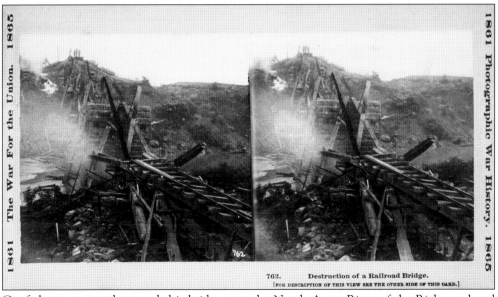

Confederate troops destroyed this bridge over the North Anna River of the Richmond and Fredericksburg Railroad. Six bridges west of Vienna were similarly burned by the Confederates during the war and had to be replaced after the war before service could be resumed. (Photograph by Timothy O'Sullivan, courtesy of Library of Congress.)

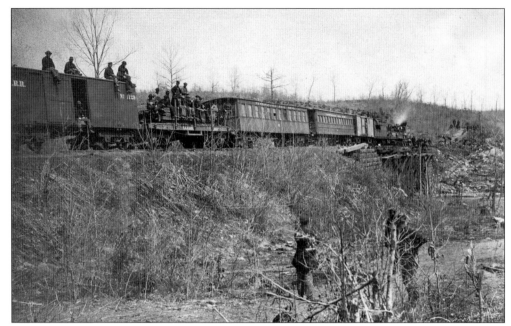

This image, *First train across Bull Run Bridge, spring of 1863,* includes typical freight and passenger cars of the Civil War era. The wheel assemblies under the cars have wood beams, and the passenger cars have simple curved roofs. A cannon barrel sticks out of the porthole on the boxcar behind the locomotive's tender—is this the first armored railcar? (Courtesy of Library of Congress.)

Bowies Bridge was named after the railroad's Second Division engineer, Robert G. Bowie, who designed it and directed its construction. The Alexandria, Loudoun & Hampshire Railroad's 1859 Examining Committee Report notes that the now completed bridge deserves special mention for its durable construction and handsome appearance. This photograph was taken from the front of eastbound Car No. 45 on May 30, 1951. (Photograph by John F. Burns Jr.)

Two
SOUTHERN RAILWAY

This chapter covers the period from about 1872 until 1912. There are relatively few images of the Bluemont Branch trains and locomotives from this period. Instead, the chapter concentrates on station structures as examples of the carpenters' efforts and hand-tool skills that were put into the railroad's buildings. The Washington & Ohio Railroad undertook new track construction, reaching Round Hill in 1874 and rebuilding stations along the way.

The Richmond & Danville Railroad originally leased the Washington, Ohio & Western Railroad on October 30, 1886. The Richmond & Danville's owner, J. Pierpont Morgan, leased the Washington, Ohio & Western Railroad to prevent it from becoming a major competitor. The grand scheme of the Alexandria, Loudoun & Hampshire Railroad—to bring coal from West Virginia and with it prosperity to Alexandria—came to an end. After leasing the Washington, Ohio & Western Railroad, the Richmond & Danville Railroad bought up all of the other railroad's outstanding capital stock and became its sole owner.

Local citizens insisted that the Southern Railway extend the line to Snickersville, which was reached in June 1900. The Southern Railway named the station Bluemont so that it would have a more pleasing name. Shortly afterward, the town renamed itself Bluemont.

Early stations consisted of a box frame covered with board-and-batten siding and a single-ridge roof covered with shingles. The Falls Church and Herndon stations were enlarged using the same siding and roof design. The Leesburg passenger station and the Bluemont station were beautiful, large structures. The exterior walls on the Leesburg and Round Hill passenger stations were embellished with fish-scale shingles. The Leesburg station had slate roofing shingles. The Bluemont Branch stations are the only railroad stations with colored-glass windows that the author has come across.

The Southern Railway conducted a general upgrading of the branch in 1904, replacing some stations, including the ones at Purcellville and Sterling, and expanding the stations at East Falls Church, Vienna, and Herndon. Ike and Fred Isaac were members of the W&OD Railroad paint gang that maintained the structures.

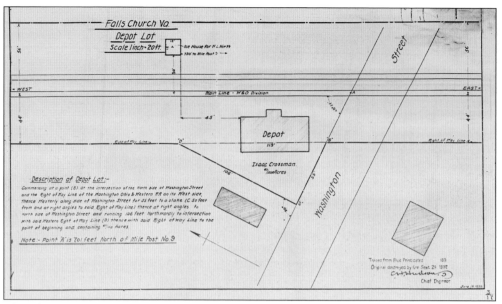

This plat shows the outline of the floor of the East Falls Church station as it appeared before September 29, 1897, when the original architectural drawing was destroyed by fire. This same structure was extended to the west with the addition of a baggage room. Washington Street is now Lee Highway. (Courtesy of Southern Railway.)

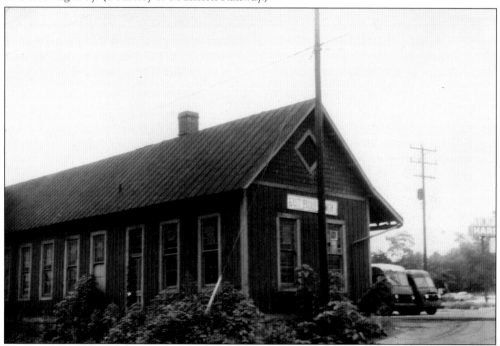

This view from July 1967 of the southeast corner of the East Falls Church station shows stained-glass windowpanes surrounding all of the upper window sashes and door transoms. Railway Express Agency trucks are parked out front. The smiling and grinning Walter Mahoney was still at work as the last East Falls Church station agent. Amos Bigsby assisted him in handling the heavy express business. (Photograph by Thomas A. Coons.)

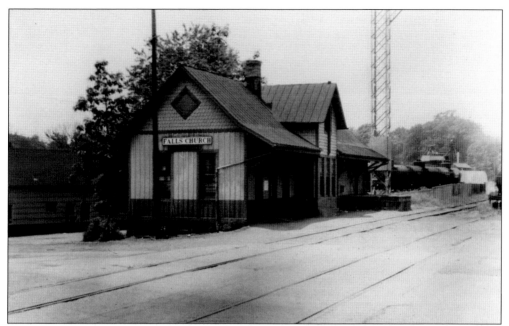

The East Falls Church station, labeled at the time as Falls Church, stands in standard Southern Railway paint colors of yellow ochre above the windowsills and hunter green below, with green trim. Other stations had white trim. The tank cars on the trestle of the Robert Shreve Fuel Company behind the station are delivering No. 2 heating oil. The fuel company also sold clunker, bird, egg, pea, and slacker coal. (Courtesy of Northern Virginia Regional Park Authority collection.)

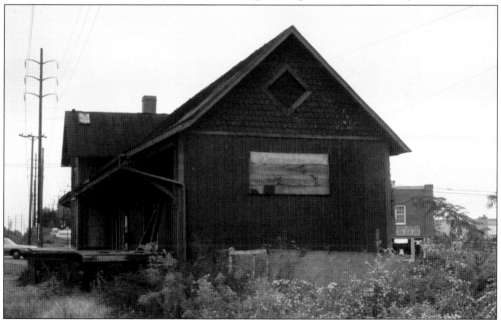

By October 1968, when this photograph of the station's west end and track side was taken, the station had been boarded up. The loading dock had been extended so that a short ramp could be placed between it and a boxcar or passenger car for unloading express and freight. (Photograph by the author.)

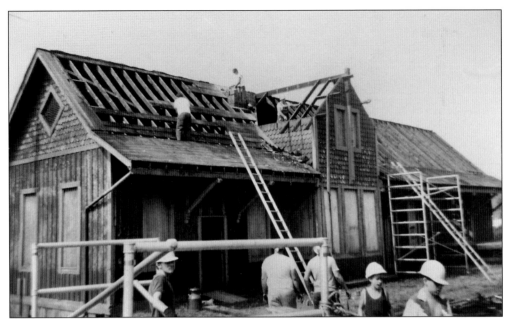

The Virginia Electric Power Company had purchased the right-of-way for its power line and was concerned that the station could burn and sever its cables. It gave the station away to the Amissville Trading Post. Here, Trading Post workmen have removed the shingles and are removing the roof boards and rafters on August 18, 1970. (Photograph by Henry H. Douglas, courtesy of Fairfax County Public Library Photographic Archive.)

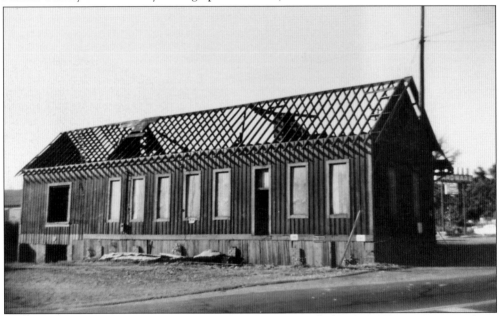

Here, on August 18, 1970, the roof boards have been removed, exposing rafters and the end wall of the original station—just to the right of the baggage door. The Blue Ridge Trading Post arranged to have the station taken down so that it could rebuild it in Amissville, eight miles west of Warrenton, Virginia, on Route 211. (Photograph by Henry H. Douglas, courtesy of Fairfax County Public Library Photographic Archive.)

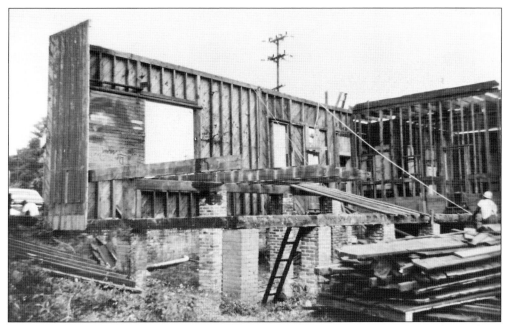

The north baggage room and west waiting-room walls of the station on the track side have been exposed in this photograph from October 10, 1970. The Southern Railway extended the station to the left in 1904, from where the two studs stand near where the left rope drapes over the wall. (Photograph by Henry H. Douglas, courtesy of Fairfax County Public Library Photographic Archive.)

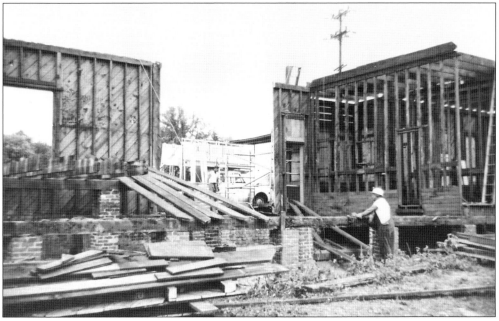

Here, Arthur L. Brown guides the tearing down of the first north wall section in October 1970. The agent's office wall studs and ceiling joists are at right. The station structure in this photograph was originally built in 1878. (Photograph by Henry H. Douglas, courtesy of Fairfax County Public Library Photographic Archive.)

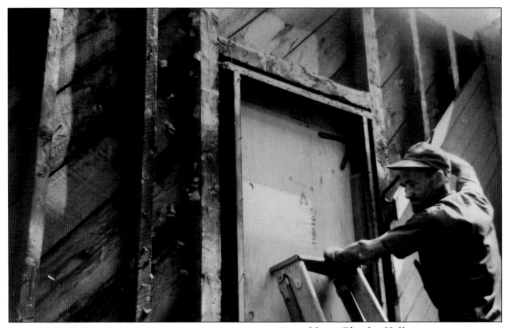

Here, Charles Kelly removes diagonal wall boards from one of the occupied station rooms on August 28, 1970. The station walls consisted of three layers of wood: the wide diagonal boards behind the studs, the narrow finished diagonal boards on the inside, and the exterior vertical boards with battens. (Photograph by Henry H. Douglas, courtesy of Fairfax County Public Library Photographic Archive.)

This chimney still stands with the interior wall boards on August 28, 1970. The flue port is visible on the lower chimney bricks just above the sloped section. (Photograph by Henry H. Douglas, courtesy of Fairfax County Public Library Photographic Archive.)

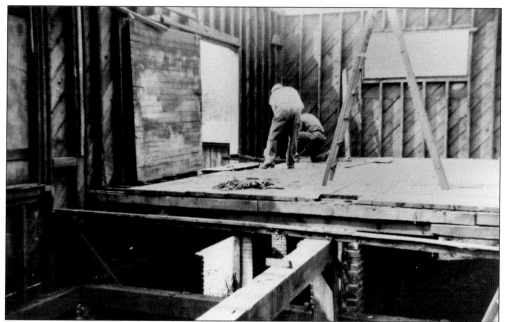

This photograph shows the internal framing for the extended freight room, including the window frame, on August 26, 1970. The south-side baggage door is at the left. The near-floor girder, from the 1904 raising of the baggage-room floor, is supported by a wooden post, while the extended floor behind it is partially supported by a brick pillar. (Photograph by Henry H. Douglas, courtesy of Fairfax County Public Library Photographic Archive.)

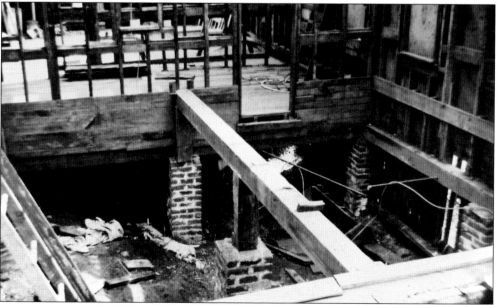

The baggage-room floor had been raised to make it easier to unload less-than-carload-size freight from boxcars and passenger cars. Here, on September 26, 1970, its floor has been removed, exposing its girder. This photograph looks east into the agent's office area and the east-end waiting room. (Photograph by Henry H. Douglas, courtesy of Fairfax County Public Library Photographic Archive.)

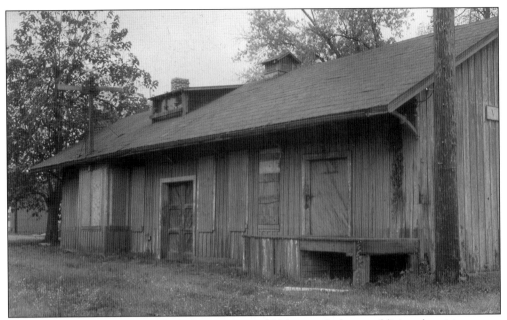

The Southern Railway modified the station in 1904 to include an additional waiting room for "colored" people, a freight office, and a telegraph office. Electric lines passed through the dormer window—still present here in October 1968—to the substation, and the cupola provided ventilation for the electrical equipment. According to Interstate Commerce Commission, Division of Valuation records, this structure was built in 1881. (Photograph by the author.)

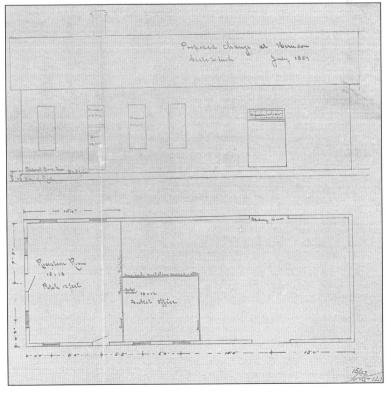

The original Herndon station included the ticket office and freight room. In July 1887, the Richmond & Danville Railroad proposed enlarging the station by adding a reception room on the east end. For a time, this station housed the Herndon Post Office. (Courtesy of Southern Railway.)

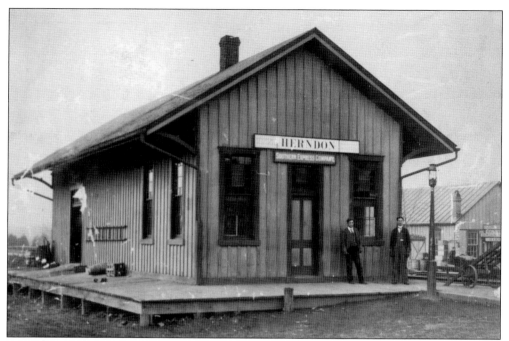

According to the Interstate Commerce Commission valuation records, the Herndon station was built in 1880. This is how it appeared around 1905, after the addition shown in the drawing. Note the stained-glass windows. This photograph shows the southeast corner. Charles S. Cooper (left) was stationmaster from 1905 to 1938. Later station agents included Donald Leith and Vernon Cockrell. (Courtesy of Green Funeral Home, Northern Virginia Regional Park Authority collection.)

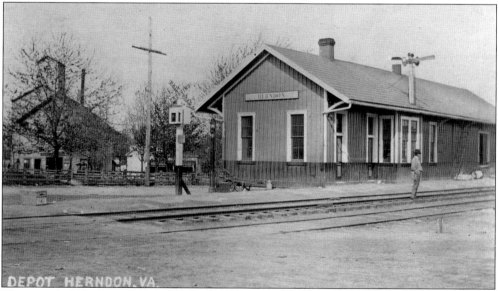

This pre-1912 photograph shows that the station has been extended again and a bay window has been added for the agent to look up and down the tracks. The baggage room shows only one baggage door. The Harrington semaphore signal has its boards pointed horizontally, indicating that the next trains in both directions are to stop and obtain train orders from the agent. (Courtesy of Northern Virginia Regional Park Authority collection.)

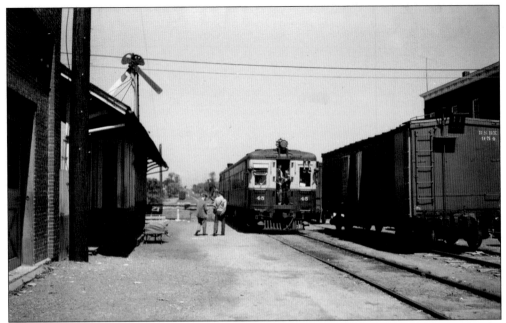

Railfans are bursting at the seams of the gas-electric Car No. 45 on May 30, 1951. The train order boards are hanging down, indicating no orders. The telephone pole supports the radio antenna that the railroad started using in the late 1940s. Note the slight downhill grade on the tracks to the west of (behind) the car. (Photograph by John F. Burns Jr.)

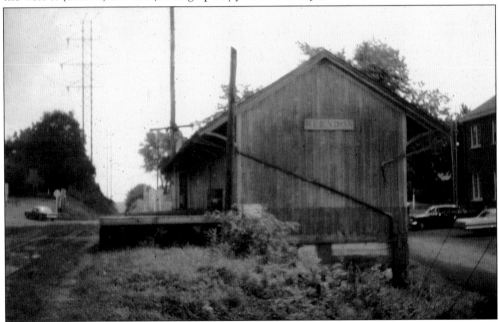

When this photograph was taken in August 1968, the railroad was just days away from abandonment. A few months later, salvage crews came through Herndon and tore up the tracks. The station's west end was extended first in 1904, and a second time after the W&OD Railway took over the property. It was cut back to make way for a Station Street realignment within a few years. (Photograph by the author.)

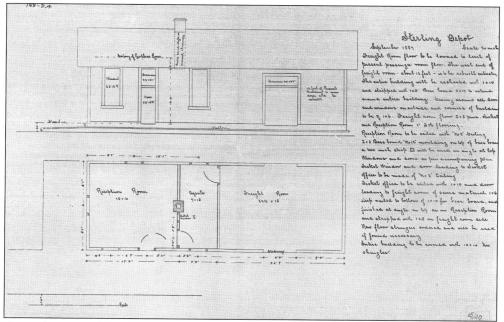

A new depot was designed for Sterling in September 1887 under the auspices of the Richmond & Danville Railroad. This drawing comprises a complete architectural plan for the building. Master carpenters of the day were able to translate this information into a completed structure. Martin Bicksler was the last Sterling station agent. His wife. Louisa Bicksler, worked as a relief station agent. (Courtesy of Southern Railway.)

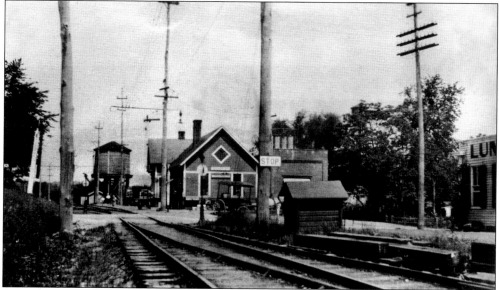

According to Interstate Commerce Commission records, the Richmond & Danville Railroad built the Leesburg station, located on South King Street, in 1888. Seen in this June 1, 1918 image, the two-story building has two waiting rooms, an express/baggage room, and an upstairs room. Other water tanks were at Alexandria, Rosslyn, Vienna, and Bluemont. The small shed next to the tank houses the steam water pump. Leesburg's substation is on the right. (Courtesy of Interstate Commerce Commission.)

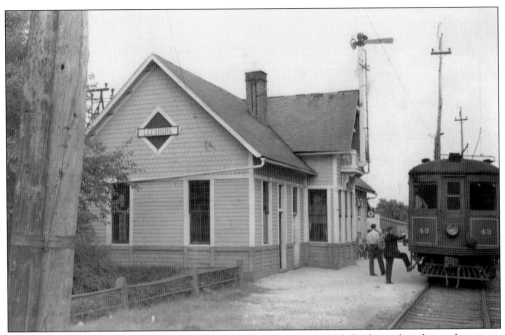

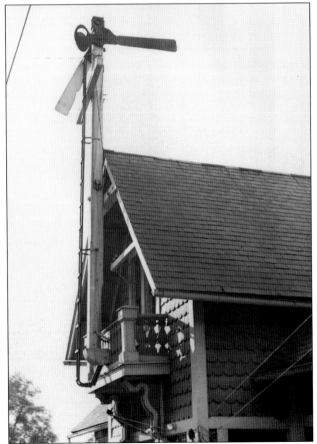

While the railroad ran electric passenger cars, the Leesburg station maintained two waiting rooms: the west end for "colored" patrons, and the east room for white patrons. Aside from Rosslyn, this was the only station to have more than one employee. The station agent oversaw a clerk/telegrapher and an express/freight clerk. Above, railfans record the last days of the electric passenger operations in April 1940. (Photograph by John F. Burns Jr.)

On July 6, 1940, the horizontal Harrington semaphore train order board at the top of the post indicates that there are train orders for the next westbound train. Notice the open circle at the left end of the horizontal board. When the board hangs down, indicating no orders, light from the lamp at the top of the post can shine through this circle, giving rise to the phrase "all clear." (Photograph by John F. Burns Jr.)

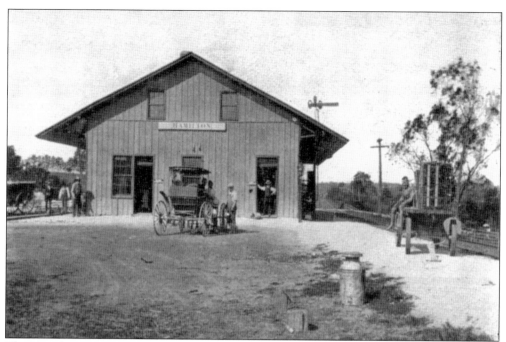

The Hamilton station, built in 1884, is among the oldest surviving stations on the line. This postcard photograph was taken before 1912 and shows the two waiting rooms in use—the left room for black passengers and the right one for white passengers. Station agents included William Watts and Joseph Beales. (Courtesy of Northern Virginia Regional Park Authority collection.)

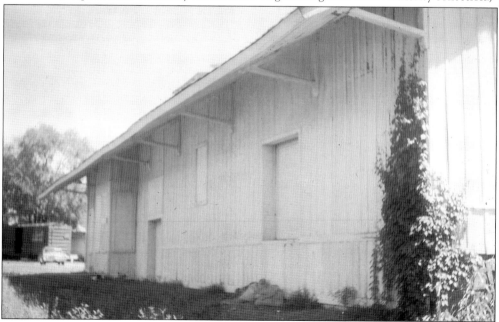

The boxcar in the distance is parked at the warehouse door of the Loudoun County Milling Company in August 1968. The dormer through which the high-voltage alternating current lines and the direct current lines entered the substation inside is visible as a little blip above the station roof. (Photograph by the author.)

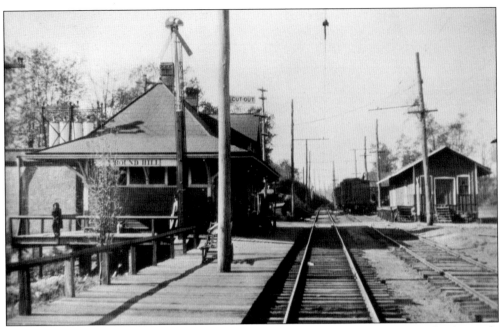

Round Hill was the branch's terminal from 1874 until 1900. The 139-foot-long and 8-foot-wide platform allowed the railroad to park the passenger cars of a train at the station clear of Main Street while the locomotive used the turntable before heading back to Alexandria. Main Street runs between the passenger and freight stations, seen here in 1916. (Courtesy of John F. Burns Jr. collection.)

In this east-facing photograph, the Round Hill trestle is beyond the track gang trailer in the center. The original passenger station burned down on January 25, 1902, and was replaced by the one seen here. The passenger station, freight station, and the electrical substation have all been remodeled into residences that are still in use today. (Courtesy of Town of Round Hill, Northern Virginia Regional Park Authority collection.)

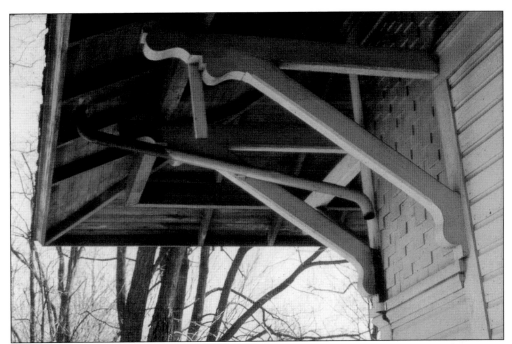

A previous owner of the Round Hill passenger station had installed a second floor with an access stairway on the front of the structure. Later remodeling moved the stairs inside and cleaned up the outside. This photograph, from March 1969, shows the eave detail under the northwest corner. The curves and corner relief on the brackets and the fish-scale shingle siding are particularly noticeable. (Photograph by the author.)

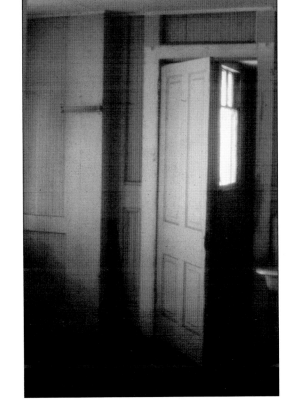

This door, on the east side of the office, leads from the agent's office out into a hallway or perhaps into one of the waiting rooms. The ceiling was installed when a previous owner added the second floor. Considering that the station was built in 1902, the door was probably handmade. Careful joinery is evident in the walls. (Photograph by the author.)

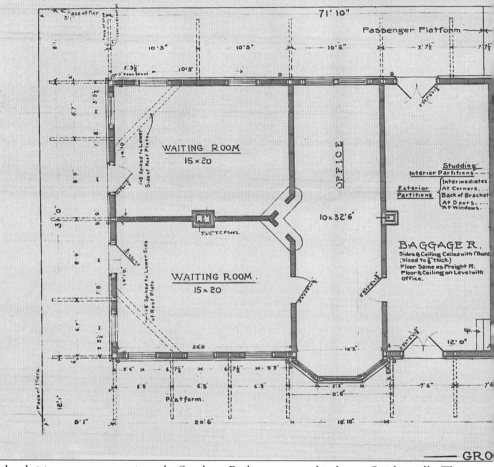

It took local citizens years to convince the Southern Railway to extend its line to Snickersville. The railway conditioned the extension on local citizen funding and the changing of the community's name to Bluemont to make it more appealing to potential visitors and summer boarders. The station was built in June 1900. This drawing shows the required segregation of "colored" and white

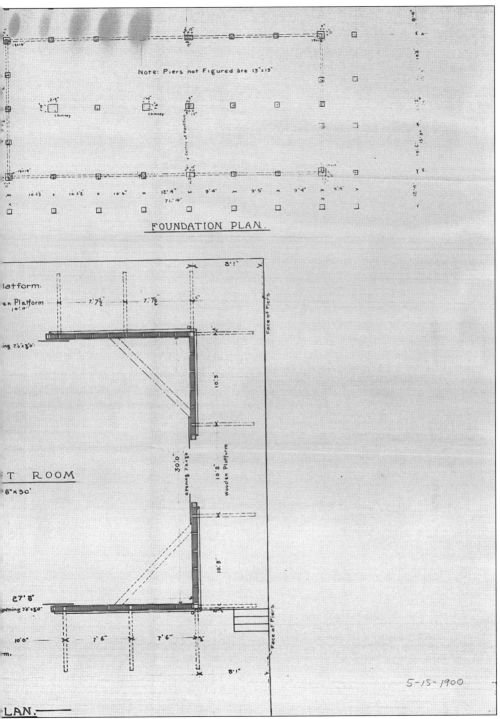

Note: Piers not Figured are 13"x13"

FOUNDATION PLAN.

5-15-1900

passengers. It also shows three flues for coal stoves, leaving the baggage room and freight rooms unheated. This station burned around 1920 and was replaced with a simple rectangular structure. The station was framed in wood with a tin-shingle roof. (Courtesy of Southern Railway.)

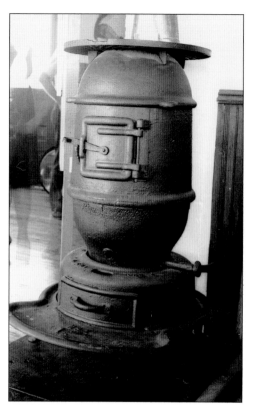

This coal stove currently resides in the Chesapeake Beach Railway Museum in Chesapeake Beach, Maryland. It came from the W&OD Railroad and is typical of the stoves used in every station on the line. This large stove was used in one of the waiting rooms. A smaller stove was used in the agents' offices. (Photograph by the author.)

The Round Hill freight house was built in 1888 before power tools. The construction methods of the time dictated using mortise and tenon joints with pegs to hold the pieces together, which were built with handsaws, chisels, and drills. The freight house was being used as a furniture repair shop when this photograph was taken in 1969. (Photograph by the author.)

Three

GREAT FALLS & OLD DOMINION RAILROAD

Wealthy entrepreneurs John R. McLean and Stephen B. Elkins undertook the development of a park at Great Falls, which eventually included a hotel, a dance pavilion, a lookout tower, refreshment stands, a carousel, and picnic grounds—as well as a railroad to reach it. The line to Great Falls ran through very rolling terrain. The cuts and fills were mostly long and in many cases quite deep, as one can still see today. The Interstate Commerce Commission reported in 1918 that the grading was done with carts and scrapers.

A *Washington Times* article from March 13, 1904 (or 1906) reports, "Trolley cars are going to be running between Georgetown and Great Falls, and the trip which now occupies several hours, and is made by means of horses and wagons, will consume less than half an hour. . . . Nearly 2,000 men are at work along the proposed line of the Old Dominion and Great Falls Railroad Company, grading for the track bed, and others are erecting the steel bridges over the numerous small creeks. . . . This army of workmen has been delayed by the continued cold weather, which froze the ground to such a depth that as much dynamite had to be used in loosening it as would be required to remove stone. Otherwise the railroad would have been in operation . . . on Memorial Day. As it is, the railroad cannot be completed before the latter part of June. To accomplish this the graders must work nearly all of the nights, as well as days."

One war worker remarked in 1918 that that particular November day "was a dull day at the Great Falls and Old Dominion zoo, you ought to see it in the summer when the fighting is really fierce. And the car leaves with ten or fifteen passengers hanging onto the tailboard." Great Falls & Old Dominion trolley cars were a welcome change to the local citizens, who had been used to traveling over dusty and muddy roads. Wading through mud to travel was becoming a thing of the past.

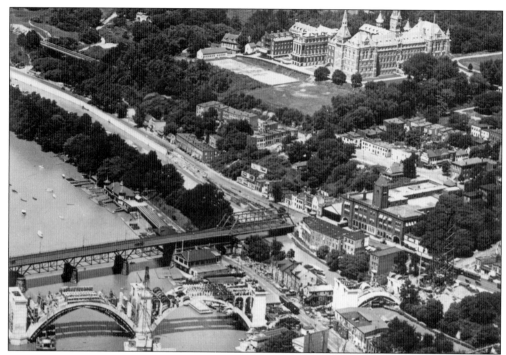

The railroad's Washington station—seen here in 1922—was located across M Street NW from the end of the Aqueduct Bridge, just to the left of the Capital Traction Union Station (at right with the square tower). It served passengers until April 27, 1924, when the bridge was closed. The station's train shed was dismantled and reerected in Rosslyn as part of the railroad's shop building. (Courtesy of National Archives.)

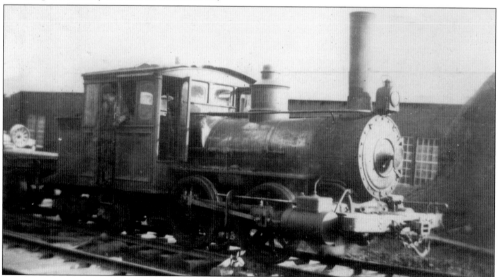

Business was booming in the late 1900s as citizens flocked to the Great Falls amusement park. Service on the Great Falls line was supplemented by diminutive steam locomotives from Manhattan pulling Manhattan elevated railway cars when the trolley cars were overloaded. The steam trains were also used when the powerhouse in Rosslyn could not generate enough electricity. (Photograph by LeRoy O. King Sr., courtesy of LeRoy O. King Jr.)

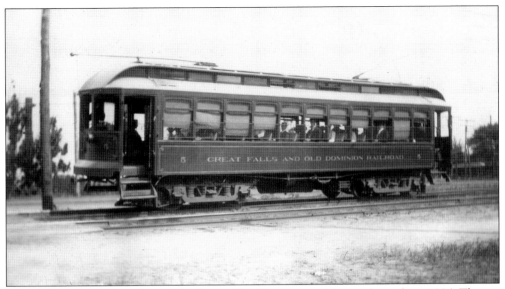

Car No. 5 was a 1904 product of the Jewett Car Company and is seen here about 1906. The car has been modified with steel sheeting to create a sloped area above the end bumper. The slope prevented patrons from catching free rides by hanging on the ends, and prevented water from coming in under the end panels and soaking the feet of the motormen. (Photograph by LeRoy O. King Sr., courtesy of LeRoy O. King Jr.)

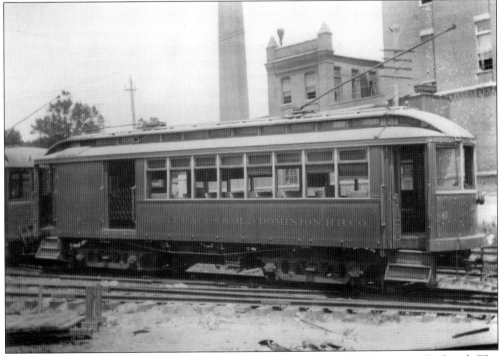

Car No. 6 was the only combination car of the Great Falls & Old Dominion Railroad. The baggage compartment was used to carry sacked mail to towns along the line. When needed, the baggage compartment could accommodate passengers. (Photograph by LeRoy O. King Sr., courtesy of LeRoy O. King Jr.)

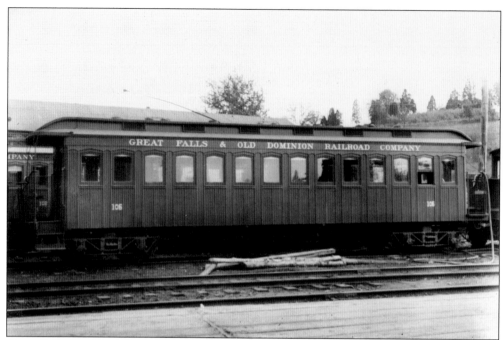

Great Falls & Old Dominion Railroad Car No. 106 was bought to supplement trolleys on the Great Falls line. The trolley pole on top of this unpowered car was used to collect current for its lights. On the right, a hose is being used to fill the water tank of the elevated steam locomotive. (Photograph by LeRoy O. King Sr., courtesy of LeRoy O. King Jr.)

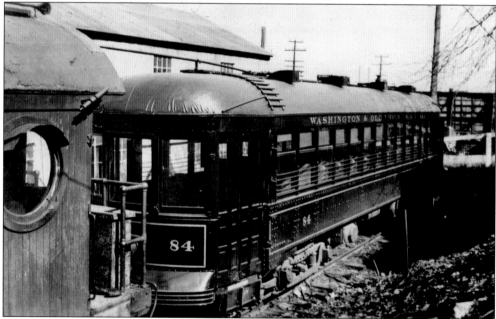

"Old 84" made her last go-round on the Great Falls line on June 8, 1934, piloted by George C. Bostwick, who had piloted cars from the first run on March 7, 1904. Passengers sang "The Last Round-Up" as they took their last ride. "Old 84" sits here behind the Rosslyn roundhouse as it waits to become a diner. (Photograph by LeRoy O. King Jr., courtesy of John F. Burns Jr. collection)

Jewell station was typical of the stations on the line. It sat on the north corner, where Rock Spring Street crosses Old Dominion Drive today. Many stations were named for the landowners who sold property to the railroad, and many had boxes where riders stored their muddy boots while they went into town. (Courtesy of John F. Burns Jr. collection.)

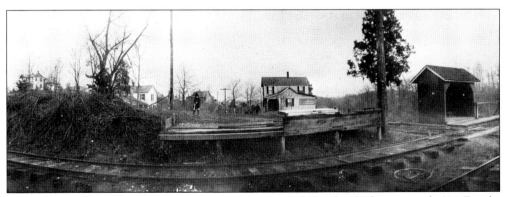

A young John F. Burns Jr. stands behind the Franklin Park freight platform around 1914. Freight trains carried coal on flatcars and would stop for their customers, who could shovel the coal onto the platform and then into wheelbarrows to take it home. (Photograph by John F. Burns Sr., courtesy of John F. Burns Jr. collection)

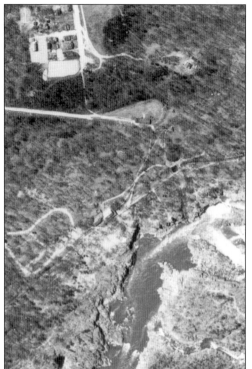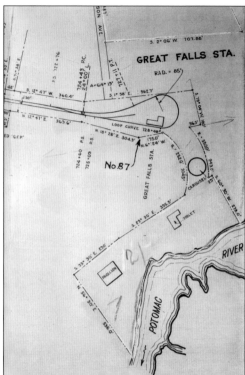

The June 1918 track plan at right shows the limited railway property at Great Falls and the locations of the station, carousel, dancing pavilion, and toilet. The aerial photograph at left, from April 19, 1937, was enlarged and oriented to match the track plan. The path of the railway's track around the station is visible in the center of the image. Perhaps the building inside the loop is the old station, which had its picnic shelter removed by this time. The round roof of the carousel is just above the falls. The Great Falls of the Potomac were said to be the Niagara Falls of the South and attracted visitors from all over the East Coast. (Right, courtesy of Interstate Commerce Commission; left, courtesy of National Archives, Record Group No. 114.)

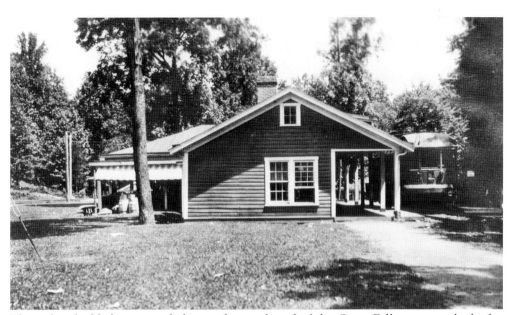

The railroad added a picnic shelter to the north end of the Great Falls station, which also protected passengers in inclement weather. Just beyond the station, the land was almost level and park visitors could run, play games, and spread out picnic materials under the trees. Train crews could stay overnight when they brought the last train in and would be taking the first train out. (Courtesy of John F. Burns Jr. collection.)

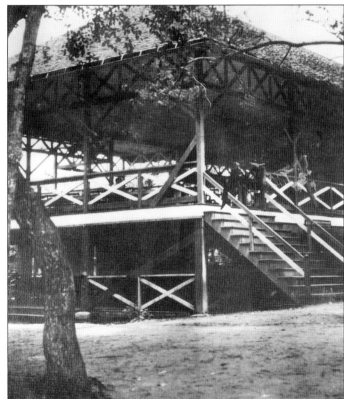

The Great Falls pavilion, seen here on June 12, 1918, was one of the main attractions. The steps led up to the dance floor, where square dancing was held on Friday nights. On Saturday nights, a four- or five-piece Washington band provided the music for waltzing and two-stepping. Concerts were also held on Sunday afternoons. The lower level had picnic tables, games, and a rotating paddle wheel for prizes. (Courtesy of Interstate Commerce Commission.)

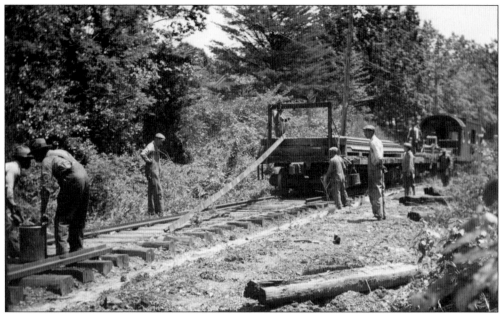

After passenger service ended, the railroad salvaged track and overhead materials. Once the spikes had been taken up, the internal bonds were removed, and the rail joint bars were unbolted; the rails were loaded onto one flatcar with the help of the winch, located on a second flatcar behind the locomotive. This photograph was taken near the Rockwell station on May 18, 1935. (Photograph by John F. Burns Jr.)

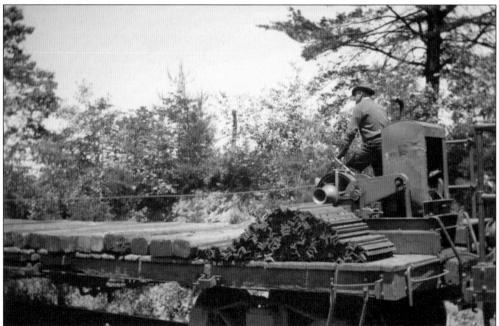

Carl Crosen ran the gasoline-powered winch on the flatcar on May 18, 1935, near Rockwell station. Ties that were worth saving for use on the Bluemont Branch of the W&OD Railroad were loaded onto the flatcar next to the locomotive. Joint bars are stacked next to Crosen in this photograph. (Photograph by John F. Burns Jr.)

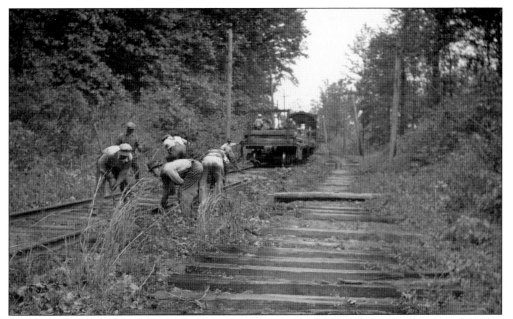

The first track of the double-track railroad had already been removed by May 21, 1935, when this photograph was taken near Vanderwerken trestle (near present-day Williamsburg Boulevard). Here, track-gang laborers remove the spikes that keep the rails on the ties. Home-built Locomotive No. 26 is pulling the work train. (Photograph by John F. Burns Jr.)

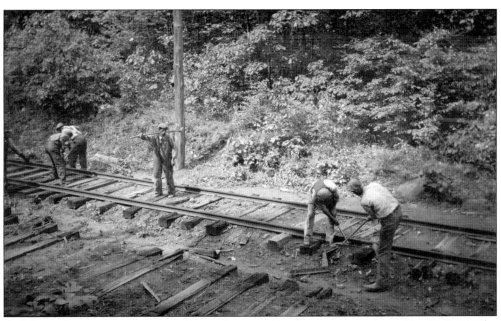

At left, track-gang members are pulling spikes near Vanderwerken trestle on May 21, 1935. The center laborer is carrying a claw bar (the end is like a lobster claw). The head of the claw is placed under a spike and the bar pushed down to pull the spike out. The two men at right are driving out an internal bond that bonded rails together electrically. (Photograph by John F. Burns Jr.)

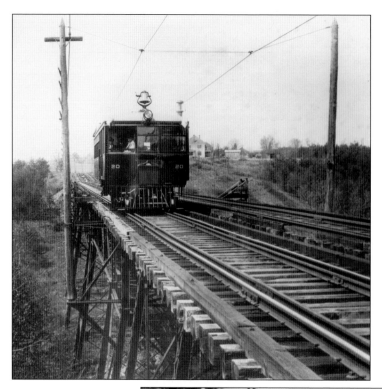

Early settlers had problems crossing Difficult Run and named it accordingly. The Great Falls & Old Dominion Railroad erected this 463-foot-long, 87-foot-high steel bridge and trestle to cross the Difficult Run ravine. Here the Mack Brothers Motor Car Company demonstrates rail bus No. 20 on the W&OD Railway—stopping on the bridge on May 23, 1920. (Courtesy of Northern Virginia Regional Park Authority collection.)

Initial construction of this trestle took over three months. Each rivet of the bridge, seen here in February 1979, may represent a half hour's labor from cutting the steel and shaping the rivet to erecting the pieces and riveting them together. The Difficult Run bridge continued to carry passenger traffic until February 13, 1979—almost 55 years after the abandonment of the Great Falls line. The bridge was replaced in 1979–1980. (Photograph by the author.)

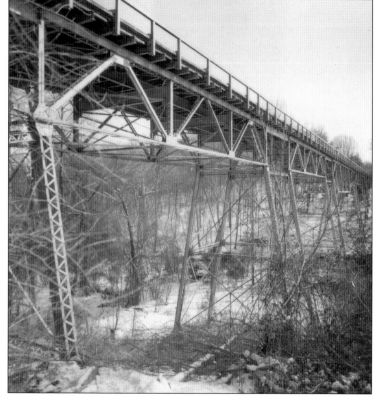

Four

WASHINGTON & OLD DOMINION RAILWAY AND RAILROAD

After the 1910s, the W&OD Railway settled down to become a quiet interurban railroad. Passenger traffic was especially brisk on the weekends, when city residents visited their families and friends in the suburbs. Buses brought competition, and the new automobiles drew more passengers from the line. By 1932, when the W&OD Railway went into receivership, the equipment and right-of-way had deteriorated, and the railroad had acquired a new nickname—"Wobbly, Old & Dilapidated." Since the passenger ridership had declined, the railroad petitioned the Virginia State Corporation Commission in 1940 to discontinue passenger service. After public debate and protest from some of the remaining riders, passenger service was allowed to end on April 12, 1941. Electric interurban passenger service was over. Two years later, with World War II material shortages bringing gas and tire rationing, the public insisted that the railroad reinstitute passenger service.

Freight service continued to provide most of the railroad's income. Industries along the railroad included the rock quarry, lumber yards, cinder block plants, livestock markets, feed mills, coal yards, gasoline and oil storage depots, cement plants, and storage warehouses. One of the interesting facets of the freight operations was how often the railroad crews used gravity to help them get a locomotive around a freight car or passenger car so they could pull it in the opposite direction. In many locations, the crews could have used passing sidings to run around cars to haul them in the opposite direction, but it was quicker to throw one switch instead of two or three, and standing cars could be left unmoved.

The railroad was the site of several fascinating operations. A Southern Railway steam switcher locomotive pulled W&OD Railway electric interurban cars the final mile into the Alexandria station. During World War II, after the arrival of the General Electric 44-ton diesel locomotives, Baldwin-Westinghouse electric locomotives were used to help the 44-ton locomotives up the grades on the Spout Run Branch; and the 44-ton locomotives were used to haul a de-motored interurban railway post office as a mail train and to haul a self-propelled, gas-electric passenger car.

WASHINGTON AND

(BLUEM

This Time Table shows the time at which trains may be expected
time stated is not guaranteed, nor does the Company ho

CIRC
Effecti
(Subjec
SCHE

WASHINGTON (36th and M Streets,

WESTBOUND TRAINS

Sunday Only					Daily, Except Sunday											EA
No. 45	No. 43	No. 41	No. 39	No. 37	No. 21	No. 19	No. 17	No. 15	No. 13	No. 11	No. 9	No. 7	No. 5	No. 3	No. 1	
P. M.	P. M.	P. M.	A. M.	A. M.	P. M.	P. M.	P. M.	P. M.	P. M.	P. M.	P. M.	A. M.	A.M.	A. M.	A. M	
6.30	4.50	12.30	11.30	9.30	6.40	6.10	5.40	5.10	4.35	2.50	2.00	10.00	8.05	7.30	5.55	Lv. Wa
6.48	5.08	12.48	11.48	9.48	6.58	6.28	5.58	5.28	5.00	3 05	2.18	10.20	8.25	7.50	6.10	" Bl
6.53	5.13	12.53	11.53	9.53	7.03	6.33	6.03	5.33	5.05	3.10	2.23	10.25	8.30	7.55	6.17	" Fa
f 6.56	f 5.17	f12.56	f11.56	f 9.56	f 7.06	f 6.36	f 6.06		f 5.09	f 3.13	f 2.26	f10.29	f 8.35	f 8.04	f 6.20	" W
f 7.01	f 5.23	f 1.01	f12.01	f10.01	f 7.11	f 6.41	f 6.11		f 5.16	f 3.18	f 2.31	f10.35	f 8.43	f 8.11	f 6.25	" D
f 7.03	f 5.25	f 1.03	f12.03	f10.03	f 7.13	f 6.43	f 6 13		f 5.18	f 3.20	f 2.33	f10.37	f 8.45	f 8.13	f 6.27	" W
f 7.07	f 5 29	f 1.07	f12.07	f10.07	f 7.17	f 6.47	f 6.17	5.47	f 5.23	f 3.24	f 2.37	f10.42	f 8.49	f 8.18	f 6.31	" Vi
f 7.13	f 5.36	f 1.13	f12.18	f10 17	f 7.23	f 6.53	f 6.23		f 5.32	f 3.33	f 2.43	f10.50	f 9.01	f 8.32	f 6.42	" Hi
f 7.20	f 5.44	f 1.20	f12.20	f10.24	f 7.30	f 7.00	f 6.30		f 5.41	f 3.40	f 2.50	f11.00	f 9.08	f 8.38	f 6.49	" W
7.25	5.51	1.25	12.25	10 29	7.36	7.05	6 35	6.05	5.49	3.45	2.55	11.08	9.13	8.44	6.54	" He
f 7.34	f 6.01	P.M.	f12.34	f10.38	f 7.45	f 7.16	P. M.	f 6.14	f 6.01	f 3.54	f 3.04	f11.20	f 9.22	f 8.53	f 7.03	" St
f 7.44	f 6.12		f12.44	f10.48	f 7.55	f 7.26			f 6.13	f 4.04	f 3.14	f11.35	f 9.32	f 9.03	f 7.16	" As
f 7.49	f 6.18		f12.49	f10.53	f 8.00	f 7.31			f 6.20	f 4.09	f 3.19	f11.42	f 9.37	f 9.08	f 7.21	" Be
8.00	6 30		1.00	11.04	8.11	7.42		6.40	6.40	4.20	3.30	11.54	9.50	9.19	7.32	" Le
P. M.	f 6.40		P.M.	f11.14	P. M.	P. M.		P. M.	6.50	P. M.	f 3.40	f12.04	A.M.	f 9.29	A.M.	" Cl
	f 6.43			f11.17					6.53		f 3.43	f12.07		f 9.32		" Pa
	f 6.48			f11.21					6.58		f 3.47	f12.12		f 9.36		" Ha
	f 6.57			f11.29					7.07		f 3.55	f12.21		f 9.45		" Pu
	f 7.05			f11.38					7.16		f 4.03	f12.29		f 9.53		" Ro
	7.15			11.47					7.25		4.12	12.40		10.02		Ar. Bl
	P. M.			A. M.					P. M.		P. M.	P. M.		A. M.		

All trains, except Nos. 10 and 15, will stop on signal at Torrison, Fostoria, Clarkes Crossing,

LOCA
Washington=Bluemo
Leave Washington for Bluemont Junction and intermediate stations—A. M.—6.20, 7.00, 7.40, 8.20, 9.00,
Leave Bluemont Junction for Washington and intermediate stations—A. M.—6.40, 7.20, 8.00, 8.40, 9.20,

ALEXANDRIA—

No. 49	No. 47	No. 35	No. X-53	No. 33	No 31	No. 29	No. 27	No. X-51	No. 25	No. 23	
P. M.	A. M.	P. M.	P. M.	P. M.	P. M.	A. M.	A. M.	A. M.	A. M.	A. M.	
6.12	9.09	6.00		3.42		9.58	9.05		7.18	5.59	Lv. Al
f 6.18	f 9.15	f 6.06		f 4.41	f 3.48	f10.04	f 9.14		f 7.24	f 6.05	" Al
6.27	9.24	6.15	5.09	4.50	3.57	10.13	9.20	8.02	7.33	6.14	" Ba
f 6.30	f 9.27	f 6.18	f 5.12	f 4.53	f 4.00	f10.16	f 9.23	f 8.05	f 7.36	f 6.17	" Gl
6.33	9.30	6.21	5.15	4.56	4.03	10.19	9.26	8.08	7.39	6.20	Ar. Bl
P. M.	A. M.	P. M.	P. M.	P. M.	P. M.	A. M.	A. M.	A. M.	A. M.	A. M.	

All Trains will stop on sign

"f" Stop on signal

W. B. EMMERT,
General Manager.

WASHINGTON

705 Fifteenth Street, Northwest. 905 F S

Timetable 1B, effective on October 6, 1912, was the second timetable of the W&OD Railway. It covers passenger trains operating between Washington, DC, and Bluemont with connecting service to Alexandria at Bluemont Junction. Four trains operated in each direction between Washington, DC, and Bluemont, the end of the line, during the week and on Saturday, with only two trains operating each way on Sunday. Six westbound trains terminated at Leesburg and one

IVISION)

d depart from stations named, but their arrival and departure at the

nsible for any delay or any consequences arising therefrom.

No. 1-B

r 6, 1912.

out notice)

TWEEN

—BLUEMONT JUNCTION—BLUEMONT

	EASTBOUND TRAINS															
	Daily, Except Sunday											Sunday Only				
	No. 2	No. 4	No. 6	No. 8	No. 10	No. 12	No. 14	No. 16	No. 18	No. 20	No. 22	No. 38	No. 40	No. 42	No. 44	No. 46
	A. M.	A. M.	A. M.	A. M.	A. M.	A. M.	A. M.	P. M.	P. M.	P. M.	P. M.	A. M.	A. M.	P. M.	P. M.	P. M.
Ar.	6.40	7.25	8.00	8.30	9.10	9.50	11.50	12.50	4.25	6.05	8.20	9.50	11.00	2.46	4.30	6.53
Lv.	6.22	7.07	7.42	8.12	8.54	9.33	11.32	12.31	4.04	5.44	8.02	9.33	10.42	2.22	4.12	6.35
"	6.17	7.02	7.37	8.07	8.49	9.28	11.27	12.26	3.59	5.39	7.57	9.28	10.37	2.17	4.07	6.30
"	f 6.14	f 6.59	f 7.84	f 8.04	f 9.24	f11.24	f12.23	f 3.55	f 5.36	f 7.54	f 9.24	f 10.34	f 2.14	f 4.04	f 6.26
"	f 6.09	f 6.54	f 7.29	f 7.59	f 9.17	f11.19	f12.18	f 3.49	f 5.27	f 7.49	f 9.17	f 10.29	f 2.09	f 3.59	f 6.19
"	f 6 07	f 6.52	f 7.27	f 7.57	f 9.15	f11.17	f12.16	f 3.47	f 5.27	f 7.47	f 9.15	f 10.27	f 2.07	f 3.57	f 6.17
"	f 6.03	f 6.48	f 7.23	f 7.53	8.38	f 9.10	f11.13	f12.12	f 3.42	f 5.28	f 7.43	f 9.10	f 10.23	f 2.03	f 3.53	f 6.12
"	f 5.57	f 6.42	f 7.17	f 7.47	f 9.01	f11.07	f12.06	f 3.33	f 5.17	f 7.37	f 9.01	f 10.17	f 1.57	f 3.47	f 6.03
"	f 5.50	f 6.35	f 7.10	f 7.40	f 8.52	f11.00	f11.59	f 3.23	f 5.10	f 7.30	f 8.52	f 10.10	f 1.50	f 3.40	f 5.56
"	5.45	6.30	7.05	7.35	8.22	8.44	10.55	11.54	3.15	5.05	7.25	8.44	10.05	1.45	3.35	5.51
"	f 5.36	A. M.	A. M.	f 7.26	f 8.14	f 8.32	f10.46	f11.45	f 3.04	f 4.56	f 7.16	f 8.32	f 9.56	P. M.	f 3.26	f 5.38
"	f 5.26	f 7.16	f 8.20	f10.36	f11.35	f 2.58	f 4.46	f 7.06	f 8.20	f 9.46	f 3.16	f 5.28
"	f 5.21	f 7.11	f 8.18	f10.31	f11.30	f 2.46	f 4.41	f 7.01	f 8.13	f 9.41	f 3.11	f 5.23
"	5.10	7.00	7.50	7.50	10.20	11.19	2 34	4.30	6.40	8.00	9.30	3.00	5.12
"	A. M.	A. M.	A. M.	f 7.40	A. M.	f11.09	f 2.24	P. M.	f 6.30	f 7.50	A. M.	P. M.	f 5.02
"	f 7.37	f11.06	f 2.21	f 6.27	f 7.47	f 4.55
"	f 7.32	f11.01	f 2.16	f 6.22	f 7.42	f 4.47
"	f 7.28	f10.53	f 2.07	f 6.13	f 7.33	f 4.47
"	f 7.14	f10.45	f 1.59	f 6 04	f 7.24	f 4.39
Lv.	7.05	10.36	1.50	5.55	7.15	4.30
						A. M.		A. M.	P. M.		P. M.	A. M				P. M.

on Heights, Smith, Lawson, Ivandale, and Scotland Heights to receive or discharge passengers.

CE

ion—Time 18 Minutes

11.00, 11.40. P. M.—12.20, 1.00, 1.40, 2.20, 3.00, 3 40, 4.20, 5.00, 5.40, 6.20, 7.00, 7.40, 8.20, 9.00, 9.40.

11.20, 12.00. P. M.—12.40, 1.20, 2.00, 2.40, 3.20, 4.00, 4.40, 5.20, 6.00, 6.40, 7.20, 8.00, 8.40, 9.20, 10.00.

JUNCTION

	No. 24	No. X-52	No. 26	No. 28	No. 30	No. 32	No. X-54	No. 34	No. 36		No. 48			No. 50
	A. M.	A. M.	A. M.	A. M.	A. M.	P. M.		P. M.	P. M.		A. M.			P. M.
Ar.	6.46	8.36	9.56	10.46	4.26	5.51	6.50	10.11	7.11
Lv.	f 6.40	f 8.30	f 9.50	f10.40	f 4.20	f 5.45	f 6.44	f 10.05	f 7.05
"	6.81	7.57	8.21	9.41	10.31	4.11	5.07	5.36	6.35	9.56	6.56
"	f 6.28	f 7.54	f 8.18	f 9.38	f10.28	f 4.08	f 5.04	f 5.33	f 6.32	f 9.53	f 6.53
Lv.	6.25	7.51	8.15	9.35	10.25	4.05	5.01	5.30	6.29	9.50	6.50
	A. M.	A. M.	A. M.	A. M.	A. M.	P. M.	P. M.	P. M.	P. M.		A. M.			P. M.

to receive or discharge passengers.

discharge passengers.

J. V. DAVIS,
General Freight and Passenger Agent.

T OFFICES :

west. 36th and M Streets, Northwest.

train terminated at Herndon. Leesburg, Herndon, Bluemont Junction, and Bluemont each had wye track arrangements so steam locomotives could be turned around to face in the direction of travel. The left side of the timetable contains westbound trains, and the times are read down the columns. On the right side, the eastbound train schedules are read from the bottom up. (Courtesy of W&OD Railway.)

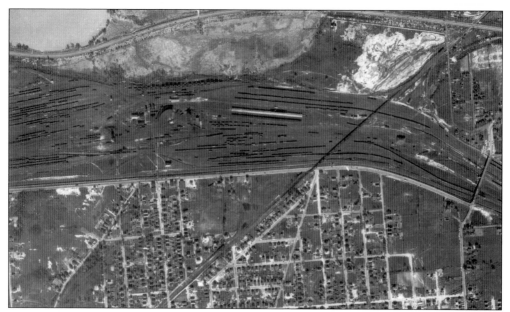

The W&OD Railroad viaduct over the Potomac yards shows up as a dark diagonal line running from the lower center to the upper right of this image. Just below the white splotchy area, the W&OD Railroad had two curved tracks, one on either side of the viaduct, which connected the railroad to the Potomac yards. The broken shadow on the left side of the viaduct in this April 30, 1937, photograph suggests that there is a W&OD Railroad train on it. (Courtesy of National Archives, Record Group No. 114.)

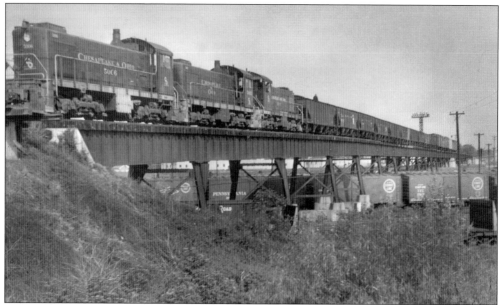

Three American Locomotive Company engines lead a freight train across the viaduct over the Potomac rail yard. Sometimes, W&OD Railroad crews had to make four passes over this viaduct to assemble one day's train. Traffic was especially heavy when the railroad was carrying sand and gravel for the construction of Dulles International Airport. (Courtesy of Northern Virginia Regional Park Authority collection.)

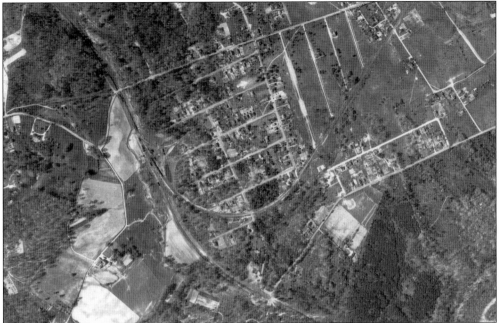

Wilson Boulevard runs across the top of this April 30, 1937, photograph. The Bluemont Branch tracks run from the lower center to the upper left. The ladle-shaped track that ends at the upper right is the branch from Bluemont Junction to Rosslyn. Where the dipper end of the ladle meets the main line is Bluemont Junction. The end of the wye track arrangement ran between Sixth and Seventh Streets. (Courtesy of National Archives, Record Group No. 114.)

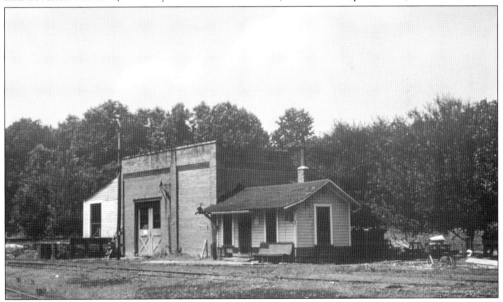

Freight train crews would use a tin cup to sprinkle sand on the rails in front of a locomotive's wheels for traction when the rails were covered with frost or ice. Sand was trucked in and dumped behind the chief dispatcher's office—the wood structure on the right—and dried on a coal stove inside. Daily, the crews then carried the buckets of dried sand to refill the locomotives' sandboxes. (Photograph by Leonard W. Rice.)

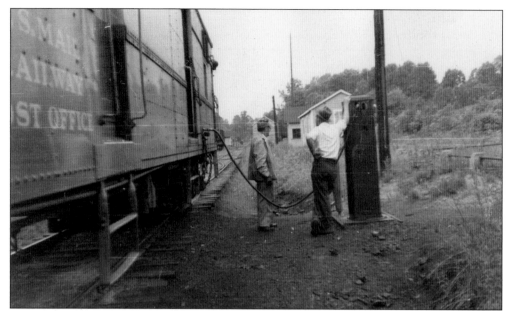

Engineer Foster R. Ormsbee is fueling the gas-electric Car No. 45 at Bluemont Junction. The tall pole in the middle of the background supports the radio system antenna that the railroad used to communicate with its train crews. The fuel came from a tank just out of the picture to the right, near the eastbound Rosslyn Branch track. (Courtesy of Northern Virginia Regional Park Authority collection.)

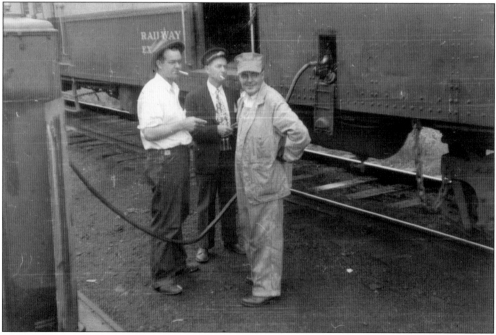

Here, brakeman Milton G. Riley (left), conductor Dolph N. Cunningham (center), and engineer Foster R. Ormsbee take a few minutes to chat while they fill the fuel tank of Car No. 45, which stands on the main line between Alexandria and Bluemont. (Courtesy of Northern Virginia Regional Park Authority collection.)

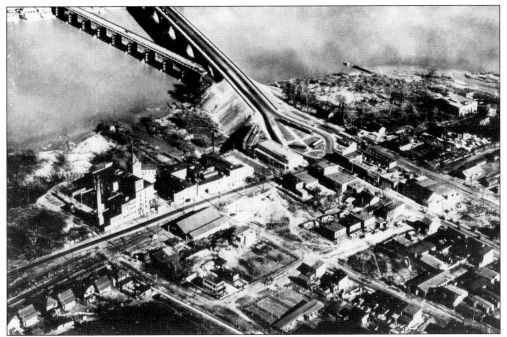

The Rosslyn passenger terminal stood where the Key Bridge Marriott Hotel is today. The passenger terminal was the railroad's pride and joy, opening on December 9, 1923. The station had a white waiting room with a refreshment stand and a Capital Traction ticket office, a "colored" waiting room, a ticket office, a dispatcher's office, and train crew spaces on the ground floor. The railroad's general offices were on the second floor. (Courtesy of National Archives.)

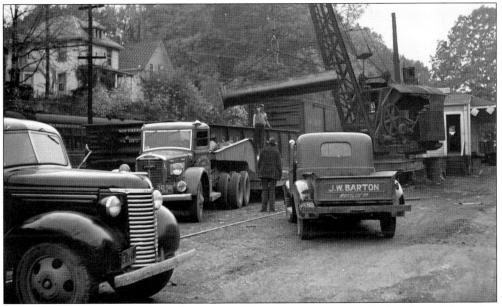

Shop crane No. 175 unloads pipe from a gondola car on a team track in Rosslyn in November 1941. At one time, teams of horses pulled wagons up to freight cars to pick up their shipments. The freight house in the background has been converted into a storage building, while freight held for customers was handled out of the shop building. (Photograph by John F. Burns Jr.)

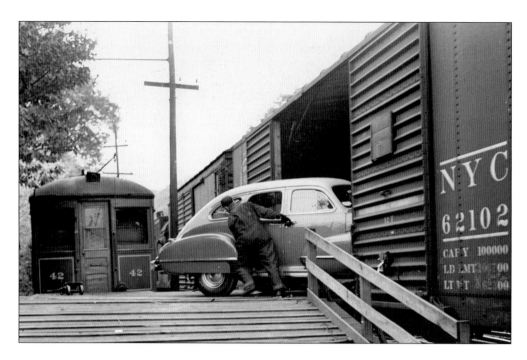

The railroad built an extra-wide dock on the south side of the Rosslyn yards to unload automobiles from boxcars. Above, the train crew is unloading 1942 Cadillac Series 61 cars from New York Central boxcar 62102 in November 1941. Each boxcar carried four Cadillacs. The boxcar's internal mechanical loader raised two cars towards the roof so two more cars could be placed under them. The car jack sitting on the left side of the dock was probably used to swing the ends of the Cadillacs out of the boxcar door so the crew could unload them the rest of the way. Below, cars are lined up waiting for the dealer's drivers. (Both photographs by John F. Burns Jr.)

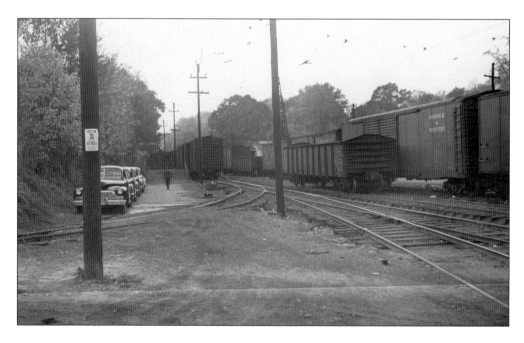

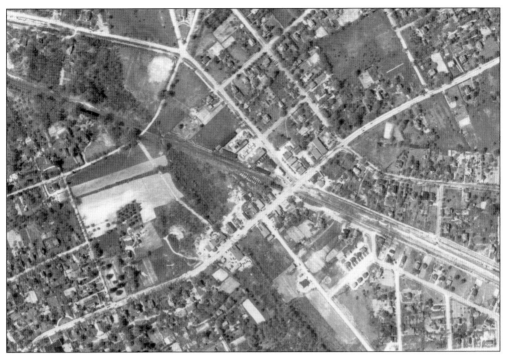

The East Falls Church station is just south of the tracks and to the left of Lee Highway in this April 30, 1937, photograph (see plat on page 20). The coal bins of the Robert Shreve Fuel Company show up as a series of hash marks to the left of the station. The Murphy and Ames Lumber Company was across the tracks, where stacks of lumber show up in a lighter color. (Courtesy of National Archives, Record Group No. 114.)

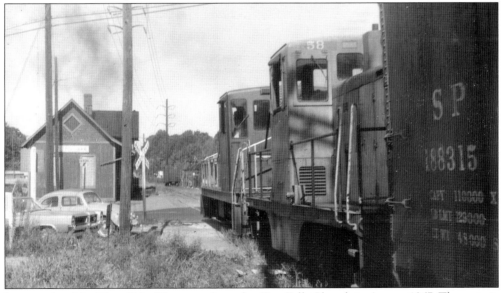

Locomotives No. 57 and No. 58 are westbound at East Falls Church in August 1967. The train is crossing Lee Highway. The station has been closed and the semaphore train order board is long gone. The flagman protecting the train from vehicles is on the right side of the train. (Photograph by Thomas A. Coons.)

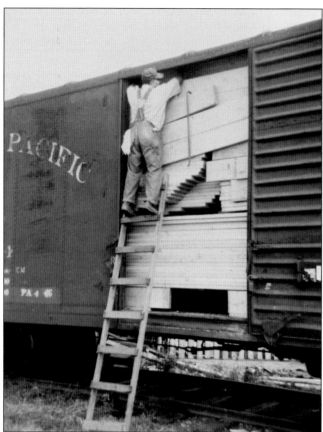

A Murphy and Ames Lumber Company workman struggles with lumber that shifted in transit. Murphy and Ames was on the north side of the tracks, just a little west of the East Falls Church station. It received the last boxcar shipment before the railroad was abandoned. (Photograph by Henry H. Douglas, courtesy of Fairfax County Public Library Photographic Archive.)

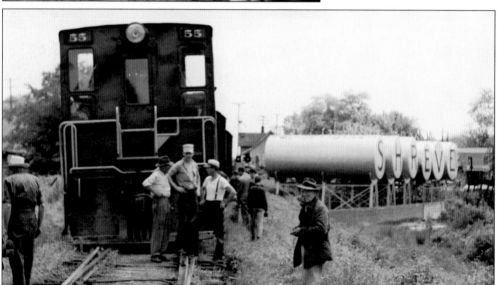

No. 55, a 75-ton Baldwin-Whitcomb locomotive, derailed completely and pulled one freight car partially off of the rails on May 30, 1951, just before eastbound car No. 45 arrived carrying railfans on the second-to-last day of passenger service. The locomotive derailed while pushing three cars onto Robert Shreve Fuel Company siding. (Photograph by John F. Burns Jr.)

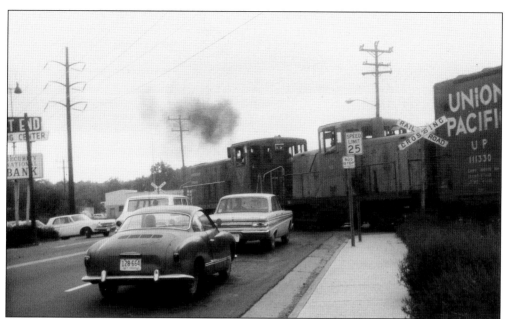

Here, Locomotives No. 57 and 58 cross Broad Street West at the West End Shopping Center. Today, a trail bridge crosses Broad Street here. This photograph suggests that there would have been major traffic conflicts in Northern Virginia if the railroad had survived—imagine a half-mile-long freight train crossing Broad Street at 6:00 p.m. at 15 miles per hour. (Photograph by Thomas A. Coons.)

This W&OD Railroad train crosses over Interstate 495, the Washington Beltway, just to the north of the current Interstate 66 interchange and the Metro's Orange Line. (Photograph by Thomas A. Coons.)

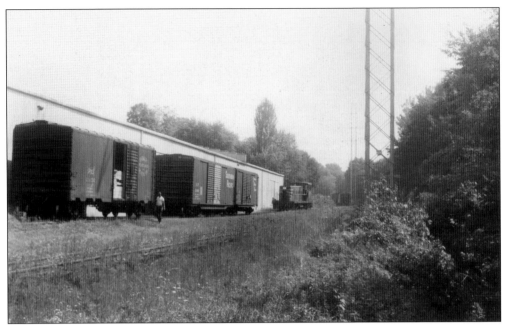

Locomotive No. 57 switches cars at Lowe's Hardware Store in October 1967. The Lowe's was sold and is now the site of a Whole Foods outlet on Maple Avenue West in Vienna, Virginia. (Photograph by Thomas A. Coons.)

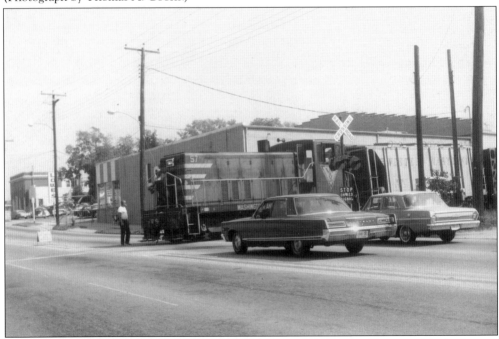

A few minutes after the top photograph was taken, Locomotive No. 57 crosses Maple Avenue West in Vienna. William W. Mahoney is flagging the train across the street. Lowe's is in the center background, behind the train. This was one of only two automatic crossing signals that operated on the W&OD Railroad, with the other at Columbia Pike in Arlington. (Photograph by Thomas A. Coons.)

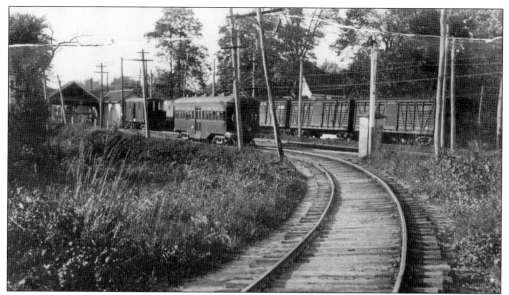

A center-door trolley car runs from the Arlington and Fairfax Electric Railway station on the east side of Church Street in Vienna towards Oakton and Fairfax City. The train in the background belongs to the W&OD Railway. Cattle and horses were part of the freight carried by the railroad, especially to the pens in Leesburg and Purcellville. (Courtesy of Town of Vienna.)

Between 1954 and 1968, the A. Smith Bowman Distillery operated the Sunset Hills station as a contract post office, which allowed the distillery to use Sunset Hills as its town of origin. Here, Douglas Lee blows his warning horn for the crossing of Old Reston Avenue in the 1950s. Sunset Hills was the last station to have a post office. (Photograph by David Marcham, courtesy of Northern Virginia Regional Park Authority collection.)

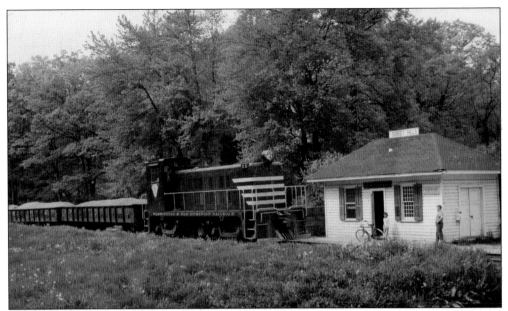

Locomotive No. 55 pulls cars loaded with crushed stone past the Sunset Hills station from the Trap Rock quarry, possibly towards the facilities of Arlington Asphalt Company or the Northern Virginia Concrete Company on the Rosslyn Branch of the railroad. (Photograph by David Marcham, courtesy of Northern Virginia Regional Park Authority collection.)

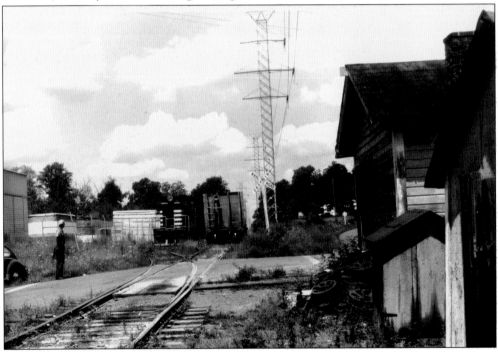

Locomotive No. 55 switches cars at a lumber dealer on the east side of Herndon at Van Buren Street in August 1967. Brakeman Arthur W. Cole is protecting the crossing. The Herndon track-gang toolshed is on the right. Old track-gang trailer-car wheels are stacked in front of the toolshed. (Photograph by Thomas A. Coons.)

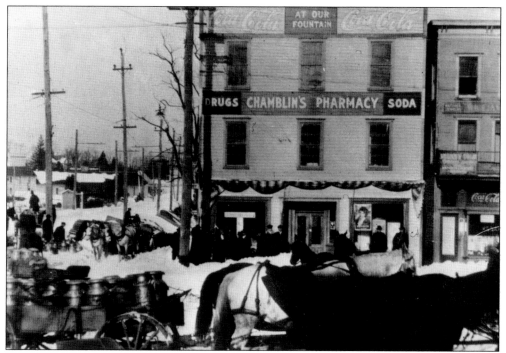

Herndon was the center of a very prosperous dairy farming area. Here, farmers have brought their milk cans into Herndon to meet the early-morning milk train. The train took the cans to Rosslyn, where they were trucked to Washington, DC, dairies for processing. Empty milk cans were returned the next morning. The Chamblin's Pharmacy building still stands across the trail from the station. (Courtesy of Herndon Historical Society, Northern Virginia Regional Park Authority collection.)

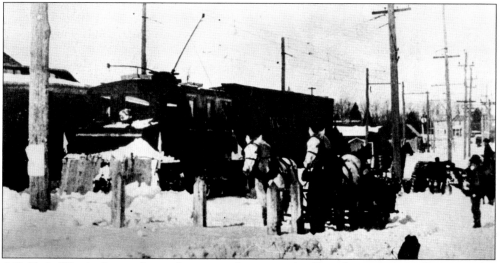

A Baldwin-Westinghouse electric locomotive has stopped at Herndon with the milk train in this 1920s photograph, possibly made on the same day as the top photograph. The railroad's shop forces have built a makeshift snowplow of wood planks and attached it to the front of the locomotive. The W&OD Railroad boxcar was one of only two owned by the railroad. (Courtesy of Herndon Historical Society, Northern Virginia Regional Park Authority collection.)

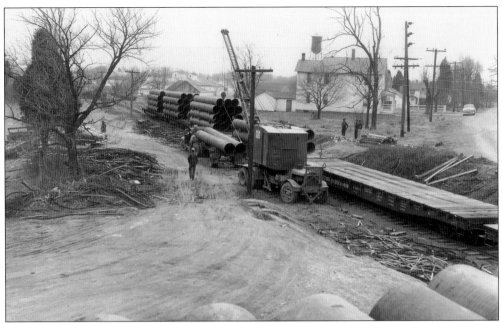

The crane above unloads pipe for a Continental Gas Company project on March 19, 1950. Looking south, the house still stands at 764 Grace Street in Herndon. The pipes had to be unloaded from the cars in several hours because they were blocking the main line. When the freight train returned eastbound, the locomotive would push the cut of empty cars east, up-grade, past the station. It would then start them rolling westward. A brakeman would uncouple the locomotive from the cars while another brakeman switched the locomotive into a siding, threw the switch back, and let the cars roll down-grade past the locomotive, following the conductor's order to "jerk 'em on by." The pipe farm below may have been in a field just to the north of Park Avenue. (Both, courtesy of Rust Archive, Thomas Balch Library, Leesburg, Virginia, Winslow Williams Collection.)

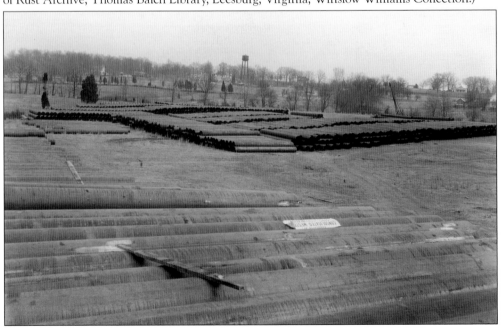

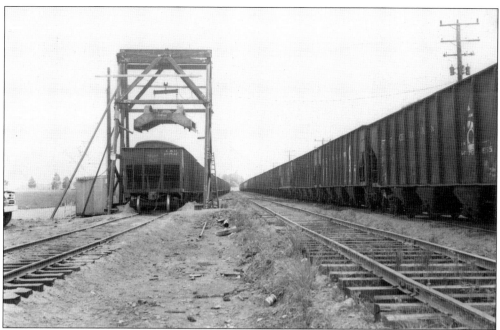

The last major construction project the railroad participated in was the initial construction of Dulles International Airport. The railroad built this temporary yard to hold the inbound cars while they were unloaded. The railroad carried thousands of hopper loads of sand and gravel, sometimes in trains with as many as 80 cars. The facility at left shook the cars to get the sand and gravel out. The photograph below shows the pit where dump trucks would back up under the shaker. This yard was just west of Route 28. (Both, courtesy of Northern Virginia Regional Park Authority collection.)

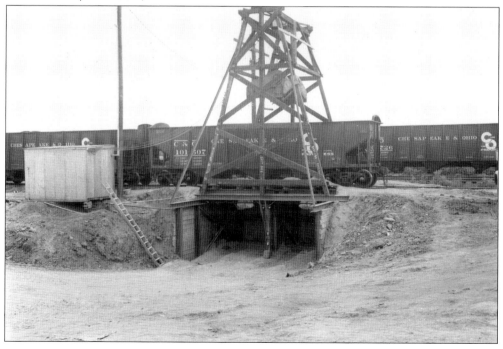

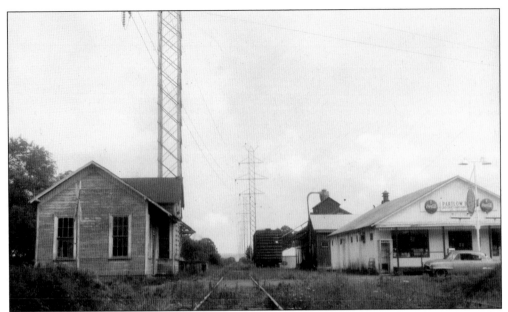

The Ashburn Milling Company was an infrequent railroad customer. This boxcar is at the Ashburn mill in August 1967. The Partlow Brothers grocery and hardware store building at the right now houses a Carolina Brothers Pit Barbeque. The mill buildings have been converted into a furniture store, where some of the mill machinery is still present on the second floor. The station has been torn down. (Photograph by Thomas A. Coons.)

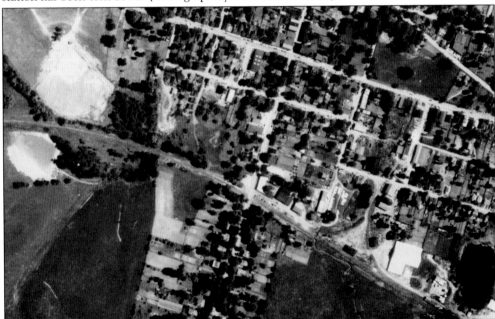

This June 2, 1950, aerial photograph shows the rails in Leesburg, including the wye. The area was known as the "wharf" because it was near Tuscarora Creek. Water was pumped from the creek into the water tank during the steam era (see page 29). The passenger station is above the tracks on the left side of South King Street. The freight station sits inside the wye, just above the squiggly line of the creek. (Courtesy of US Department of Agriculture, ASCS-APFO.)

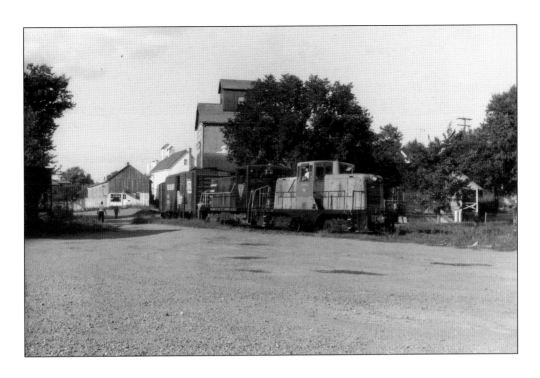

The north end of the wye included mill buildings, a fertilizer operation, and a coal trestle. In these photographs, Locomotives No. 57 and 58 are switching cars on the blind industrial wye in Leesburg in September 1967. (Both photographs by Thomas A. Coons.)

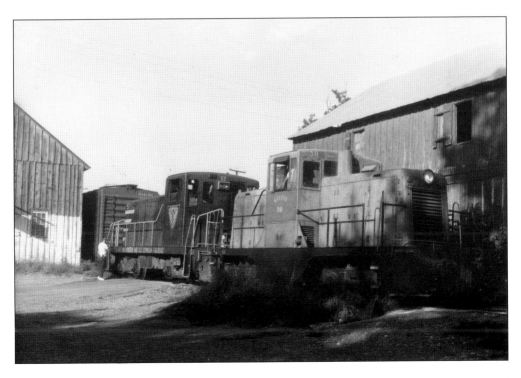

65

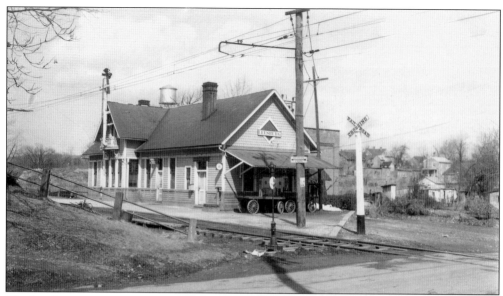

The Leesburg passenger station is nearing the end of its heyday in this 1941 photograph. Station agents, who supervised the telegrapher and freight clerk at the freight house, included Charles A. English, James Sutphin, and William Rice, a second trick station agent. John M. McLaney started his career here as a Morse telegrapher, copying down train orders, selling tickets, and answering the telephone. (Photograph by Joseph A. Weyraugh, courtesy of Maria Weyraugh.)

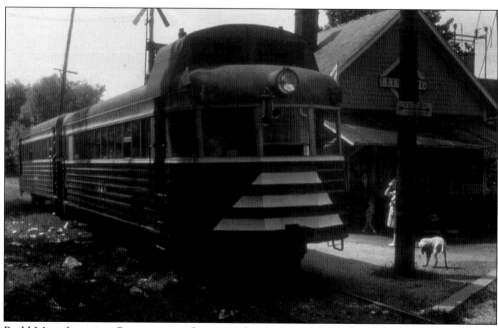

Budd Manufacturing Company cars have just finished a westbound trial run on April 27, 1943. The cars were part of the design efforts leading up to the streamlined Pioneer Zephyr passenger train. The W&OD Railroad purchased the cars from the Pennsylvania Railroad to reinstate passenger service. (Photograph by Leonard W. Rice.)

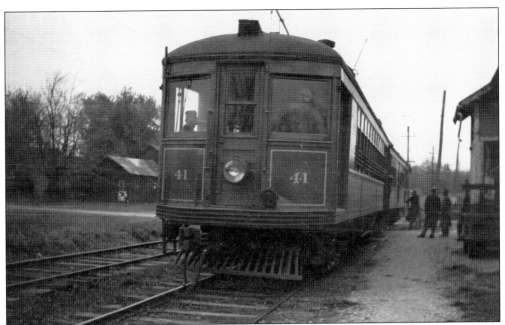

John F. Burns Jr. took a fan trip on October 29, 1938, from Rosslyn to Bluemont and back. Here, Cars No. 41 and 44 have stopped at Paeonian Springs on their trip westward. Aside from the station, the community also had a mill. Paeonian Springs was a resort town for visitors from Washington and other places. (Photograph by John F. Burns Jr.)

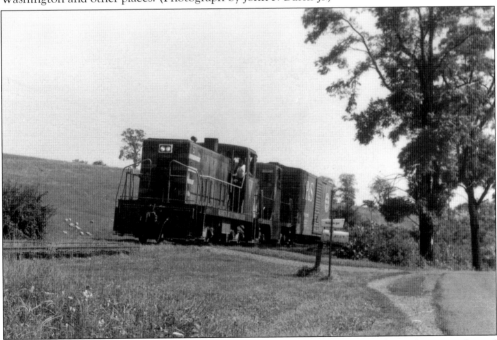

In a scene reminiscent of a Lucius Beebe photograph, Locomotives No. 57 and No. 58 are westbound in this September 1967 photograph, heading towards Purcellville. They are passing alongside Dry Mill Road a little south of Clarkes Gap, where old Route 7 passed over the railroad. Much of the railroad in Loudoun County had scenery similar to this. (Photograph by Thomas A. Coons.)

Locomotives No. 57 and 58 are switching freight cars at Hamilton station, which is out of the image to the left. The Loudoun County Milling Company received bulk shipments of grain on the track at right. Rail customers who did not need a private siding unloaded their shipments from the team track in the middle of the picture. (Photograph by Thomas A. Coons.)

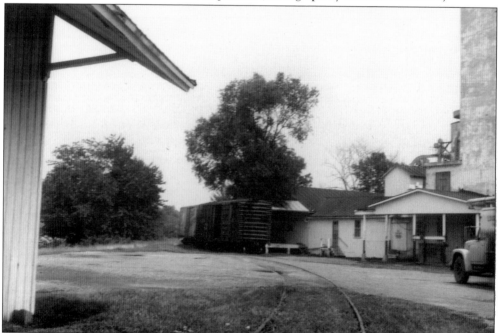

The Loudoun County Milling Company complex includes silos for bulk grain, a production area to mix custom blends of feed—including its own Loudoun Supreme Feed—a warehouse to hold bagged products, an office, and a customer dock. The mill received about three boxcars a week in the later years of bulk grains—corn, barley, Canadian oats, and soybean meal. (Photograph by Thomas A. Coons.)

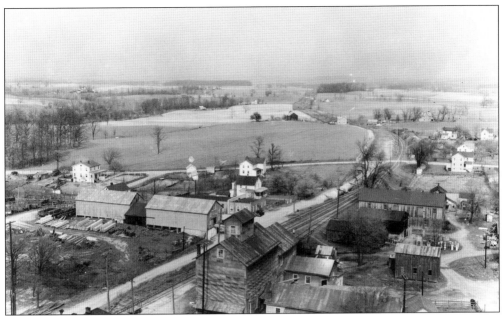

In this photograph looking east from the top of the Purcellville water tower in 1934, the Loudoun County Milling Company is front and center and the Case Brothers Lumber & Planing Mill is to the left. The third set of tracks behind the mill comprises a short run-around track that allowed Locomotive No. 49 to run around passenger car No. 46. (Photograph by Russell Gregg, courtesy of Edward Nichols, Northern Virginia Regional Park Authority collection.)

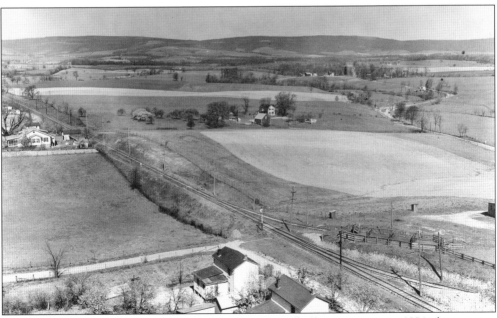

In this view looking west (left) from the top of the Purcellville water tower in 1934, the two spur sidings in the lower right provide a place to unload cattle and tank cars. In the lower center is a high-ladder switch stand. (Photograph by Russell Gregg, courtesy of Edward Nichols, Northern Virginia Regional Park Authority collection.)

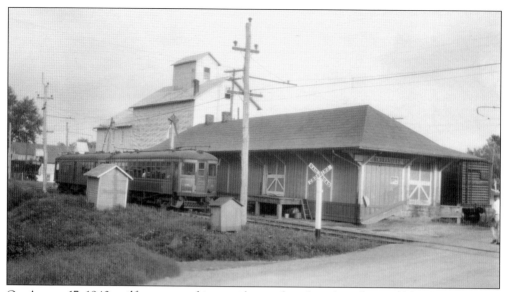

On August 17, 1940, railfans were taking a ride on what they thought would be the last day of passenger operations on the W&OD Railroad. The mill behind the Purcellville station can be seen in the bottom center of the image at the top of page 69. (Photograph by Gerald F. Cunningham.)

This high-ladder switch stand, seen here on July 6, 1940, stood west of the station in Purcellville. High stands placed the indicator paddles up where engineers could see them in time to stop their trains if the switch was turned against them. Once passenger service ended, trains no longer traveled at speeds that required the high stands, and they were replaced. (Photograph by John F. Burns Jr.)

Five

BRIDGES

The C&O purchased the W&OD Railroad in 1956, hoping to make it a viable enterprise. The C&O hoped to serve a coal-fired electric power plant and a small industrial enclave, both to be located in northeastern Loudoun County, in the vicinity of the present-day Cascades community. To support this anticipated traffic, the C&O made some money and steel available to upgrade many of the W&OD Railroad's bridges and tracks.

W. Burton Barber, the chief of maintenance of way and structures, was an all-around railroad right-of-way engineer who joined the railroad in 1947. Barber led the efforts and recorded the rebuilding of the Difficult Run, Broad Run, and Tuscarora Creek bridges. Barber was also an amateur photographer. True to the W&OD Railroad's style, secondhand—or perhaps even thirdhand—bridge steel was used. The heavier bridges were used to carry supplies for the construction of Dulles International Airport.

The railroad had one track-gang crew devoted to bridges and trestles, composed of a foreman and labor crew consisting of four West Virginia mountain men. Barber was proud of the mountain men, saying, "If you want bridge work done, go get some mountain men." With the bridge replacements, more men were needed, so members from the local section track-gang were called in.

One of the constraints on a small railroad is the need to keep the tracks open for traffic. Train crews worked on Saturdays, but liked to work early so they could get off early. The bridge span replacements took place after the freight trains had passed on Saturday and had to be ready for traffic by Monday morning.

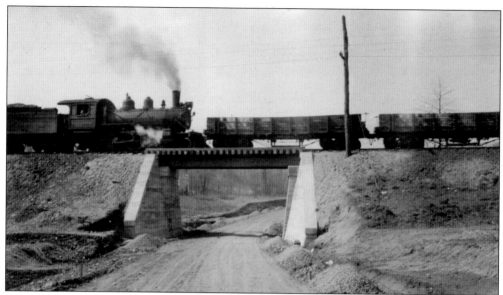

Taken in 1916, this is the only known photograph of a W&OD Railway steam locomotive working out on the line. In this case, the locomotive is pushing several W&OD Railway gondola cars over the completed Russell Road overpass in Alexandria. The gondola cars were purchased from the Pennsylvania Railroad (Class GI) in June 1916. (Courtesy of National Archives.)

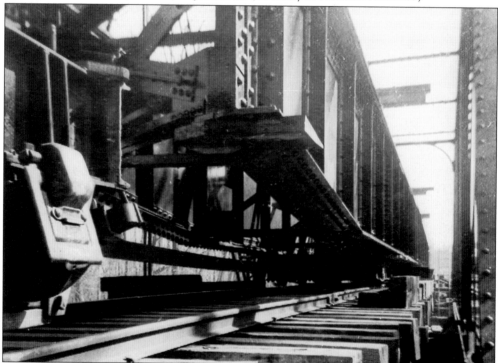

This western replacement span of the Difficult Run bridge is in position for blocking up prior to track removal in March 1959. Notice the sloped bottom end of the span. The W&OD Railroad bridge crew had to slope the pier's shelf to accept this angle. The span was designed and built as a steam locomotive turntable. (Photograph by W. Burton Barber.)

These workmen adjust the blocks under the new span of the Difficult Run bridge in preparation for the use of a 35-ton ball-bearing screw jack. This jack was also used to place the new spans at Broad Run. (Photograph by W. Burton Barber.)

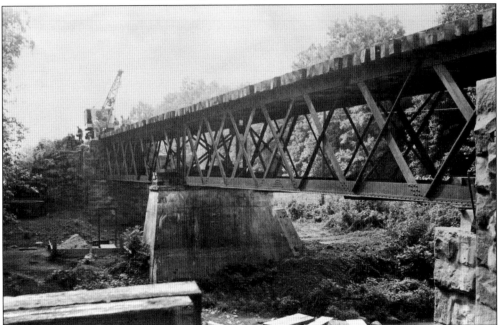

This view looks east along the north side of the bridge. Broad Run flows under the near span. The 1900-era bridge looks barely strong enough to support a small eight-wheeled steam locomotive. On the other hand, the still-standing pier looks strong enough to support a very large, 24-wheeled steam locomotive all by itself. The pier's sharp, sloped face points upstream to force floodwaters around it. (Photograph by W. Burton Barber.)

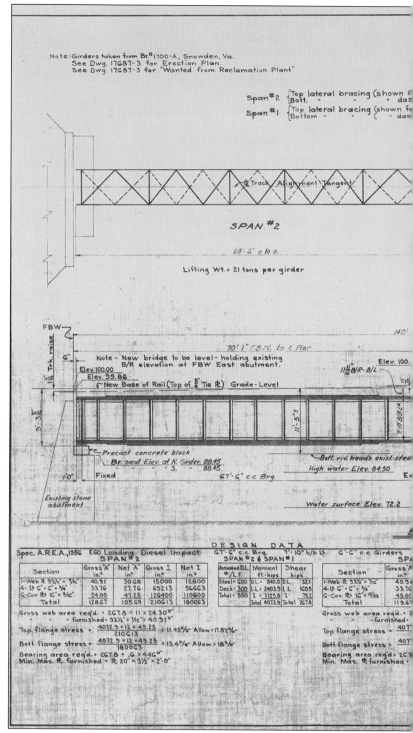

Note: Girders taken from Br.#1700-A, Snowden, Va.
See Dwg. 17687-3 for Erection Plan.
See Dwg. 17687-3 for "Wanted from Reclamation Plant"

Span #2 {Top lateral bracing (shown f... / Bott. " " " da...

Span #1 {Top lateral bracing (shown f... / Bottom " " " da...

€ Track Alignment Tangent

SPAN #2

69'-6" o to o.

Lifting Wt. = 21 tons per girder

FBW

Note – New bridge to be level – holding existing
B/R elevation at FBW East abutment.

70'-1" F.B.N. to € Pier

Elev. 100.00
Elev. 99.86
New Base of Rail (Top of ⅝ Tie ℞) Grade-Level

Elev. 100.

Precast concrete block
Br. seat Elev. at N. Girder 88.45
" 5. " 88.45 67'-6" c.c. Brg.

Bott. riv. heads exist. stee...
High water Elev. 84.50

Fixed

Existing stone abutment

Water surface Elev. 72.2

DESIGN DATA

Spec. A.R.E.A.,1956 E60 Loading Diesel Impact 67'-6" c.c. Brg. 1'-10" b/b ℓs 6'-6" c.c. Girders

| SPAN #2 | | | | | SPAN #2 & SPAN #1 | | | | SPA... |
Section	Gross "A" in.²	Net "A" in.²	Gross I in.³	Net I in.⁴	Assumed D.L. #/L.F.	Moment ft-kips	Shear kips	Section	Gross "A in.²
1-Web ℞ 53½" × ⁷⁄₁₆"	40.91	30.68	15000	12800	Steel= 650	D.L.= 5400	D.L. 32.1	1-Web ℞ 53½" × ⁷⁄₁₆"	40.5
4-1½ G"× C"× ¾"	33.76	27.76	69213	56663	Deck= 300	L.L.= 2403.9	L.L. 160.5	4-1½ 6"× C"× ¾"	33.76
C-Cov. ℞s 1C"× ⁹⁄₁₆"	54.00	47.25	126400	110600	Total= 950	I = 1125.0	I 75.2	C-Cov. ℞s 1C"× ¹⁵⁄₃₂"	45.0
Total	128.67	105.69	210613	180063		Total 4072.9	Total 267.8	Total	119.6

Gross web area req'd. = 267.8 ÷ 11 = 24.30 □
" " " - furnished = 93½" × ⁷⁄₁₆" = 40.91 □

Top flange stress = (4072.9 × 12 × 49.25) / 210613 = 11.45 ⁰⁄□ Allow.= 17.52 ⁰⁄□

Bott. flange stress = (4072.9 × 12 × 49.25) / 180063 = 13.4 ⁵⁄□ Allow.= 18 ⁰⁄□

Bearing area req'd. = 267.8 ÷ .6 = 446 □
Min. Mas. ℞ furnished = ℞ 20" × 3½" × 2'-0"

Gross web area req'd. = 2...
" " " - furnished =

Top flange stress = 407...

Bott. flange stress = 407...

Bearing area req'd = 267...
Min. Mas. ℞ furnished =

These C&O drawings from the chief engineer's office provide some interesting details. Each span is given as weighing 21 tons. The bridge girders came from a C&O bridge over the James River in Snowden, Virginia—another case of the railroad reusing materials. Compare this to the

74

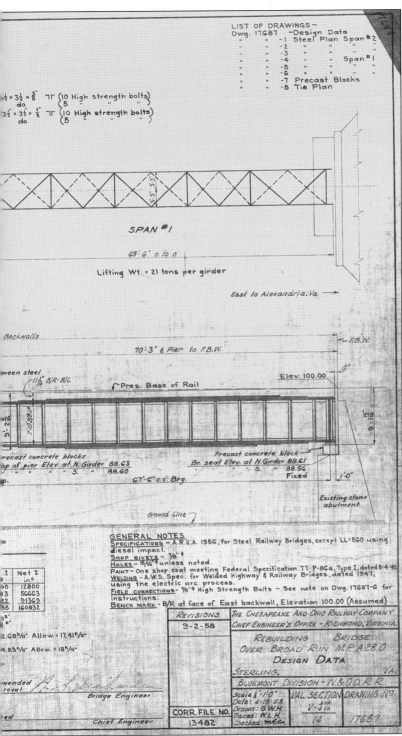

maximum 7.5-ton capacity of the railroad's Model 30 Burro crane. The new spans were designed to an American Railway Engineering Association E60 diesel impact loading, meaning they were designed to carry loads up to 60 tons. (Courtesy of Chesapeake and Ohio System Railroads.)

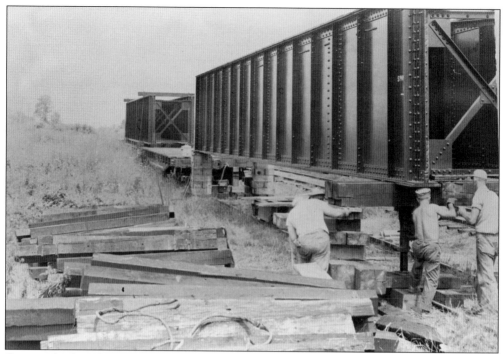

Crews unload 70-foot-long spans weighing 21 tons each. The spans were brought in on flatcars, blocked up so that the flatcars could be pulled out, and then blocked down onto a "dolly car" to be carried out onto the old bridge. The dolly car was a truck from a scrapped Burro crane. (Photograph by W. Burton Barber.)

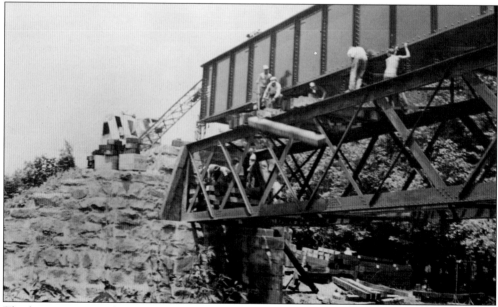

The first new span—the west one—rests on the old ties while part of the crew lays blocking inside the old span to support the new span when it is lowered into place. Another part of the crew is removing the track from under the new span. This series of photographs was taken in March 1958. (Photograph by W. Burton Barber.)

Here, the interior of the old truss span has been removed, blocking placed to support the new span, and crews are ready to start taking out the blocking. First, one layer of blocks was removed from one end, then the blocks were cleared two layers at a time, alternating ends, until the last single layer of blocks was withdrawn. (Photograph by W. Burton Barber.)

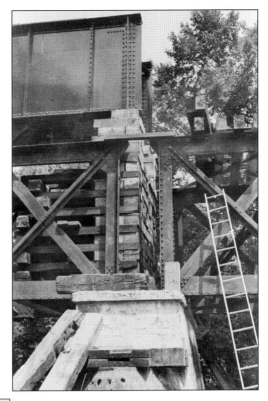

This photograph shows the jacking arrangement and jacking frame from underneath the bridge before the internal pieces of the old bridge have been cut out. The rented 35-ton ball-bearing screw jacks show as two stubs on top of the blocking, just above the end of the old span. The replacement span was fabricated to fit inside the old truss, making this method of replacement possible. (Photograph by W. Burton Barber.)

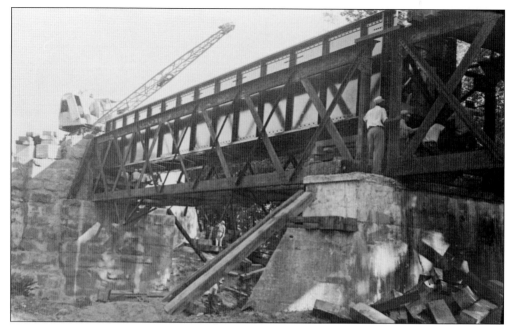

Crews lower the first replacement deck-girder span down inside the original bridge truss. Cribbing that supports the deck girder is being removed while jacks hold the girder up. Then, the jacks will be lowered so that the they can be moved down a level and the process repeated. Broad Run flows under the span between the crane and the pier. (Photograph by W. Burton Barber.)

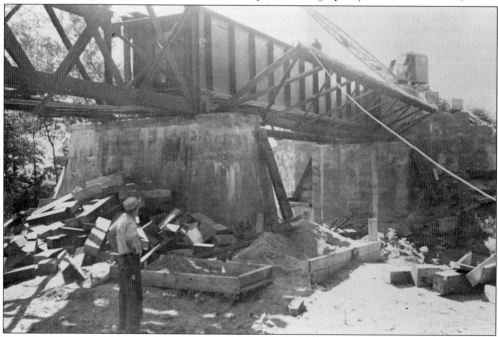

The first old span of the Broad Run bridge is being thrown down to make room for the new track ties. Once on the ground, the span will be cut up and the metal salvaged. Both approaches to the bridge run on long fills. The Broad Run bridge is about a mile west of Route 28. (Photograph by W. Burton Barber.)

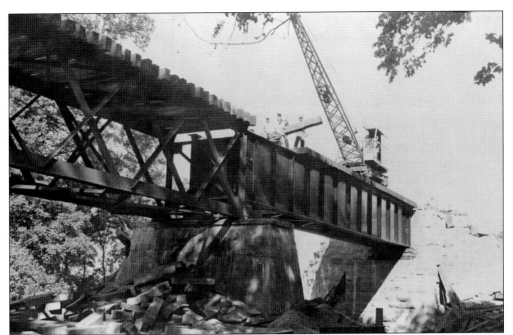

Here, the Model 30 Burro crane moves ties over the first new span for track crews to guide into place. Bridge ties are typically 10 feet long and 8.5 inches wide by 10 inches tall. Bridge ties are generally notched, as seen at the right end of the tie that is being placed, to keep them from shifting off of the bridge. (Photograph by W. Burton Barber.)

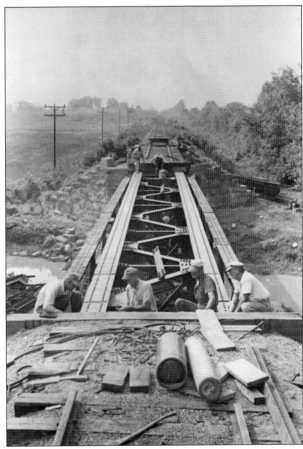

In this view looking west, the second (east) new span has been placed inside the old span. This view shows the close fit of the new span inside the old as well as the internal bracing of the new span. Track has been laid on the first span. Once the tracks on both spans were in place, guardrails were added inside the running rails. (Photograph by W. Burton Barber.)

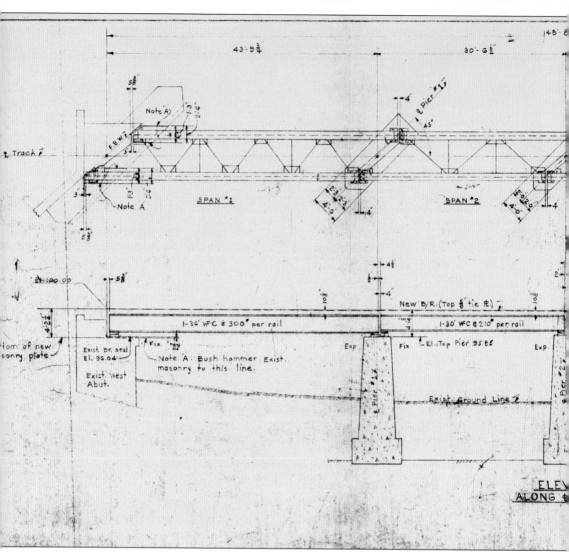

The old Tuscarora Creek bridge was at mile post 35.75, west of today's Battlefield Parkway. The single-span, through-truss bridge was 146 feet long. It was replaced with four deck-girder spans. The new piers and superstructure were designed by the C&O chief engineer's office in Richmond. The W&OD Railroad bridge and track crews constructed the piers and changed out the superstructure.

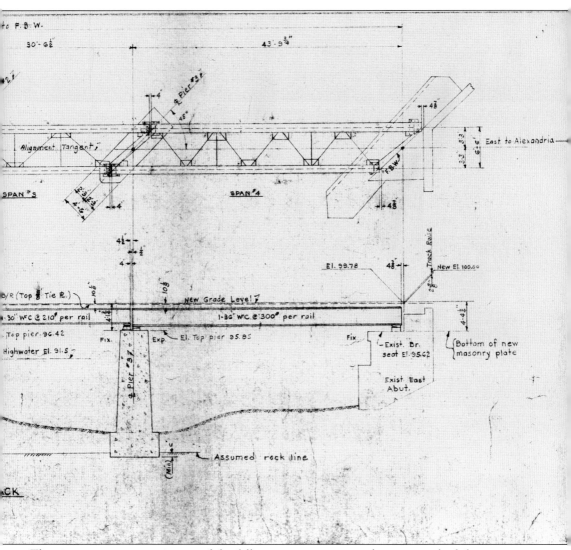

The air compressor seen in two of the following images was used to power a bush hammer to trim down the masonry shelf of the west bridge abutment. (Courtesy of Chesapeake and Ohio System Railroads.)

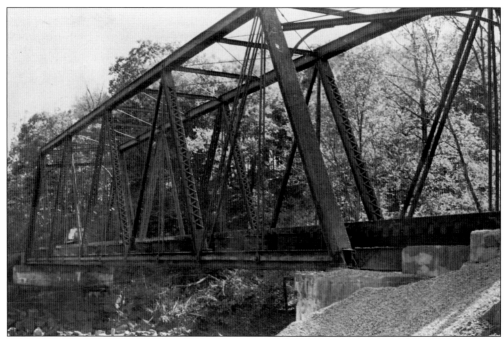

The wrought-iron Tuscarora Creek bridge was installed at its present location in the 1920s. It had previously been in use as one span of the Southern Railway bridge across the James River in Lynchburg, where it had a solid timber floor that was later replaced with a system of steel beams and stringers to carry the track. (Photograph by W. Burton Barber.)

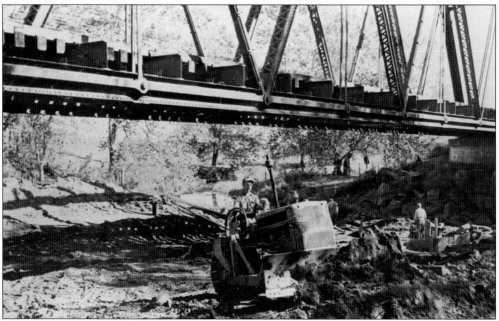

In February 1958, a bulldozer clears away the soil from under the old bridge and builds up diversion dams so that the water can be redirected while the rock is being excavated for the pier footings. Fortunately for the W&OD Railroad, the bedrock was not very far down. (Photograph by W. Burton Barber.)

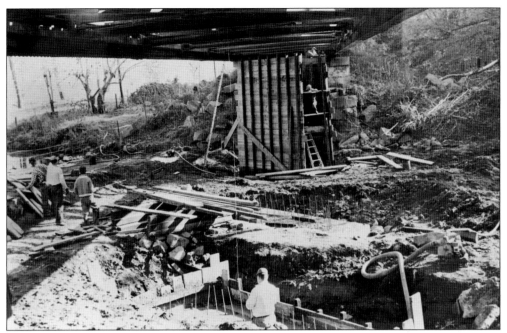

New footings have just been poured on the stone bedrock. Reinforcing bars stick up from the footings to tie them to the piers. The form for the easternmost new pier (Pier No. 3) is being built at the back of the photograph. This view shows the cross bracing underneath the old through-truss bridge. (Photograph by W. Burton Barber.)

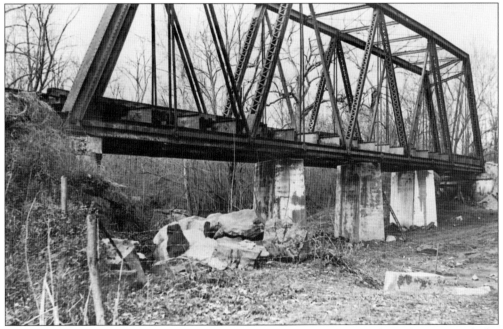

The Tuscarora Creek through-truss bridge is still in use, but the piers have been poured, the forms removed, and the site readied for the bridge's replacement. The concrete piers had to cure for perhaps a month to develop the strength to support train traffic. The east abutment is at the left of the image. (Photograph by W. Burton Barber.)

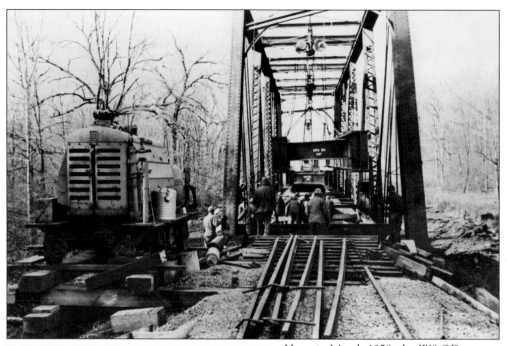

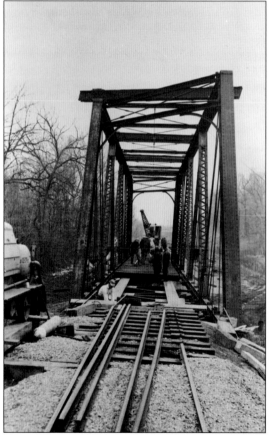

Here, in March 1958, the W&OD Railroad bridge gang has hooked a rented 25-ton chain hoist up to an I beam laid on the top members of the truss; rolled the plate girder under the hoist on a small dolly; picked up the girder; removed the dolly, track, and bottom chords of the through-truss; and then lowered the plate girder into place. Notice the transverse wheel system on the air compressor. (Photograph by W. Burton Barber.)

Here, the Burro crane is being used to lift new ties and rails onto the new spans. Once the rails have been spiked in place, trains can run again. On a single-track railroad, tying up the main line could cost the railroad per diem on any freight cars that could not be returned to their owners. (Photograph by W. Burton Barber.)

The crew cleans up for the day and the bridge is ready for trains. The I beams on top of the through-truss structure were used to support the chain hoist over each new girder's center of gravity for hoisting off the dolly cars and lowering into place on the piers. (Photograph by W. Burton Barber.)

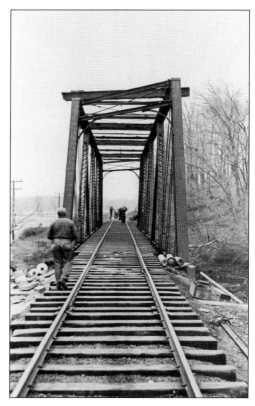

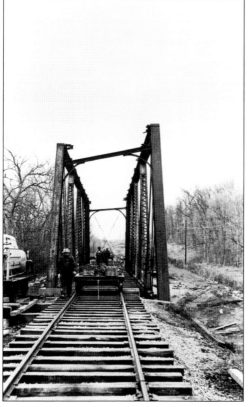

The through-truss bridge's top bracing has been removed and guy wires have been attached to keep the trusses upright until they are ready to come down. Perhaps the crew is clearing itself from inside the old truss so that the final braces can be cut and the trusses dropped. The track-gang trailer in front of the span is used to carry tools and supplies. Usually, it is pulled by a gasoline-powered speeder that has space and seats to carry a small track-gang. (Photograph by W. Burton Barber.)

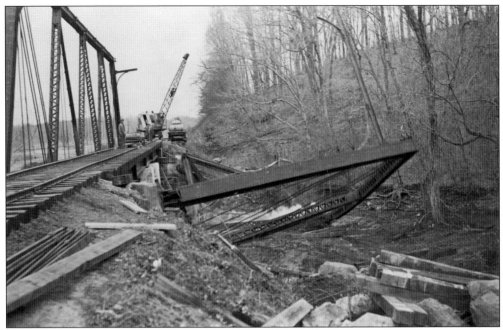

The top chords of the through-truss bridge have been cut and the northeast side has been secured in place with cables. Now, the southwest truss has been thrown down by the 7.5-ton-capacity Burro crane, hardly causing a splash in the water. (Photograph by W. Burton Barber.)

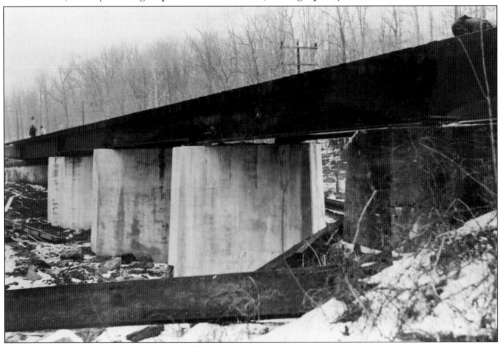

The new Tuscarora Creek bridge site still needs some more clean up in this photograph. The remaining pieces of the through-truss need to be cut up and recycled. Notice that the two center spans of the new bridge are shallower than the end spans, as seen in the drawings. The piers have been angled to minimize resistance to the flow of Tuscarora Creek. (Photograph by W. Burton Barber.)

Six

ELECTRICAL DISTRIBUTION SYSTEM

Once the power was generated or received, it had to be sent out on the line for use by the trolley cars and electric freight locomotives. For these purposes, power was transmitted as alternating current on high-tension lines at 33,000 volts on the railroad's poles. It is more efficient to transmit electrical power long distances as alternating current (AC) rather than direct current (DC). Since the high-voltage current could not be used to power the railroad's equipment, it had to be converted into a usable form at substations, which were spaced about every 7.5 miles. In the substations, the high-voltage (33,000 volts) AC was reduced to low-voltage (440 volts) AC by a transformer to run an AC motor that turned a rotary converter to create the 650 volts of DC used by the cars. Wires running from the substation to the pole near the photographer in the image on page 66 carry the operating direct current. The direct current powered the interurban cars and electric locomotives via poles and trolley wheels mounted on their roofs.

The first permanent substations were built using a standard design, with brick walls and concrete floors and roofs. The railroad purchased one portable substation that was mounted on a flatcar to serve as a backup in case the rotary converters at one of the substations needed repairs. Initially, this portable substation was sited at Vienna. Eventually, substations were added to the Vienna and Hamilton wood-frame stations and the portable substation was frequently sited at the Ashburn station.

Martin Bicksler ran the substation in the Vienna station. Nobody was allowed inside the substations. Bicksler remarked, "Don't have to touch a wire, it [electrical current] will jump out and get you." His father, David Bicksler, ran the substation at Leesburg for a time.

John M. McLaney related that the two constant causes of outages were thunderstorms and ice. Ellen Jones, who rode the train to school from Bluemont, remarked that she dreaded thunderstorms because they could make the train two hours late. John F. Burns Jr. remembered that the Great Falls trolley put on real fireworks displays during ice storms.

The railroad used two gangs to maintain the electrical system. Charles O. Bailey was the chief electrician and ran the wire gang. The other gang worked on the electrical bonds placed between each two lengths of rail.

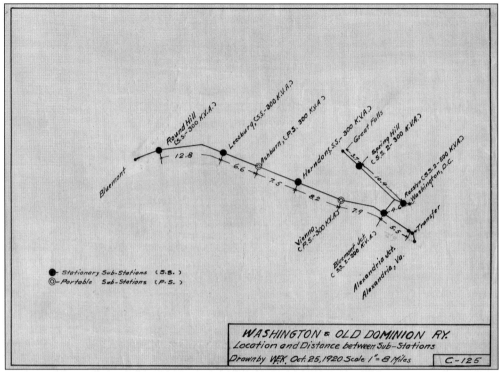

This map showing the distances and locations of the railroad's electrical substations was prepared on October 25, 1920. Permanent substation equipment had not yet been installed at Vienna, and the portable substation was being used there. (Courtesy of Washington and Old Dominion Railway, Northern Virginia Regional Park Authority collection.)

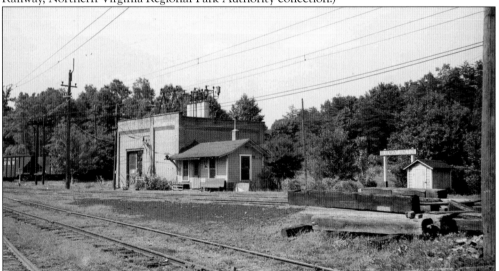

Electrical equipment at the Bluemont Junction substation included switches to turn power off west to Bluemont and east to the Potomac yards. The four white cylinders on the roof are the aluminum lightning arrestors. Above and to the right of the arrestors are three boxes containing oil-covered switches to cut the incoming high-tension power. This photograph was taken on July 21, 1940. (Photograph by John F. Burns Jr.)

Portable Substation No. 1 was caught at Ashburn on July 6, 1940. The big finned box on the near end of the substation is the step-down transformer that converts 33,000-volt current to what is needed to run the motor generators to create direct current at 650 volts. The Ashburn station, with a train order board, is behind the substation. (Photograph by John F. Burns Jr.)

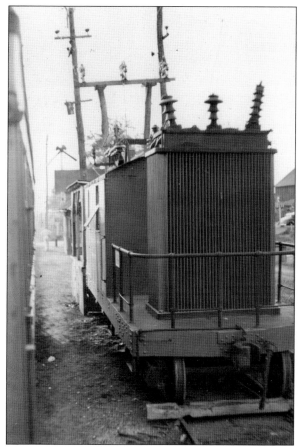

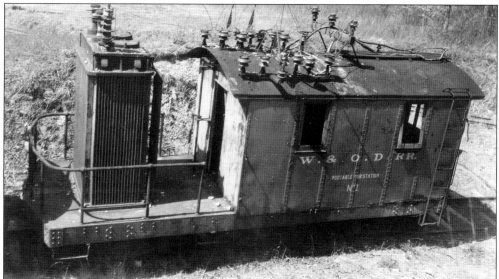

Substation No. 1 is still waiting to be scrapped in 1946 on the east leg of the wye at Bluemont Junction. The substation was built in 1912 by the Westinghouse Electric and Manufacturing Company. (Photograph by Joseph A. Weyraugh, courtesy of Maria Weyraugh.)

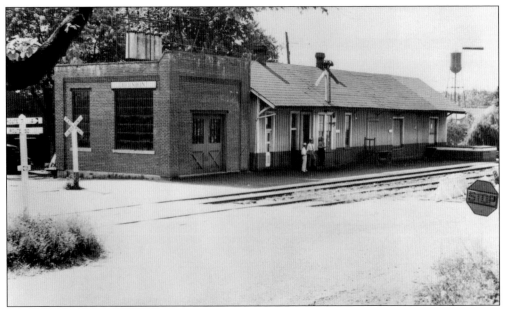

The last extension of the Herndon station's baggage room is evidenced by the new shingles in this 1930s photograph. This substation was built to a standard design that was also used at Bluemont Junction, Leesburg, and Round Hill. Herndon was an important commuter and student stop, with students from the east and west traveling to Herndon High School by train. (Photograph by LeRoy O. King Sr., courtesy of LeRoy O. King Jr.)

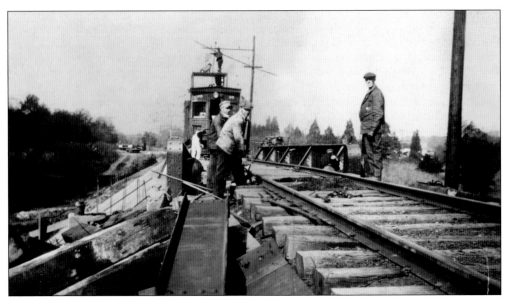

Electric Locomotive No. 25 was outfitted with a wooden platform on its roof to allow working on the catenary and overhead conductors. Here, No. 25 is working on the Lacey trestle replacement. (Courtesy of Northern Virginia Regional Park Authority, Herbert Cunningham collection.)

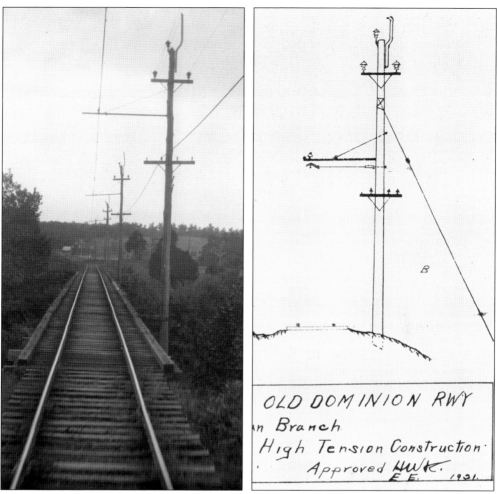

The W&OD Railway's engineer created standard drawings (right) to govern the construction of the electrical overhead. The right pole design matches those used on the main line between Alexandria and Bluemont, as seen in the left photograph, which was taken from the rear of eastbound car No. 76 on August 17, 1940. The Goose Creek bridge sits between the nearest and third-nearest line poles. Poles were spaced at regular intervals depending upon the curvature of the track. The contact wire—a hard-rolled bronze AWG size 0000—that the electric cars and locomotives drew their power from was hung from a support, or messenger, wire. In turn, the messenger wire was hung from brackets mounted on the poles. (Left, photograph by Gerald F. Cunningham; right, courtesy of Washington and Old Dominion Railway, Northern Virginia Regional Park Authority collection.)

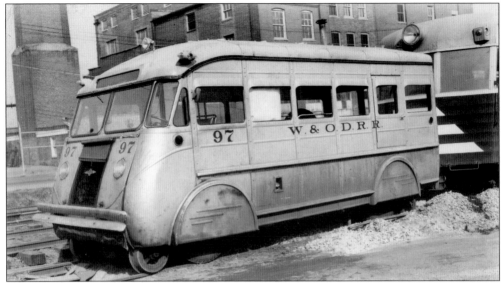

This Auto-Railer was built by the Evans Products Company of Portland, Oregon. The Auto-Railer was bought from the Arlington & Fairfax Auto-Railer Railroad in 1939 when it was ending service. Auto-Railer No. 97, formerly Arlington & Fairfax Auto-Railer Railroad No. 114, is sitting here in the Rosslyn yard about to be converted into a line car. (Photograph by Leonard W. Rice.)

Evans Products Company purchased the Arlington & Fairfax Railway that ran from Rosslyn to Fairfax City and Green Springs to convert it into a demonstration railroad using its Auto-Railer rail buses. It took down the Arlington & Fairfax Railroad's wires and reorganized as the Arlington & Fairfax Auto-Railer Railroad. In *Old Dominion Trolley Too*, John E. Merriken states that the rail bus could carry 19 passengers. (Photograph by Evans Products Company.)

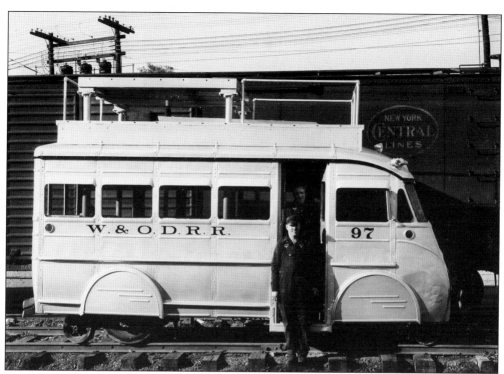

The W&OD Railroad shop forces added the elevator platform, inside stairs, and a roof hatch to convert Auto-Railer No. 97 into a line car. In this 1939 view in the Rosslyn yard, the platform is in its lowered position, ready for the Auto-Railer to be moved to its next assignment. (Photograph by Joseph A. Weyraugh, courtesy of Maria Weyraugh.)

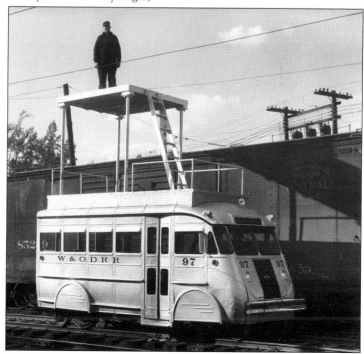

This line crew member demonstrates his ability to reach the overhead wires in Rosslyn after the platform had been raised. The ladder on top of the Auto-Railer was stored on the roof. The roof-level platform was reached via an internal ladder and a roof hatch. (Photograph by Joseph A. Weyraugh, courtesy of Maria Weyraugh.)

The ladder to the roof was permanently attached to the inside of the Auto-Railer. Perhaps a few seats were left inside so that crew members could relax while being carried to the next assignment. Unfortunately, Auto-Railer No. 97 had too long of a wheel base and frequently derailed. (Photograph by Joseph A. Weyraugh, courtesy of Maria Weyraugh.)

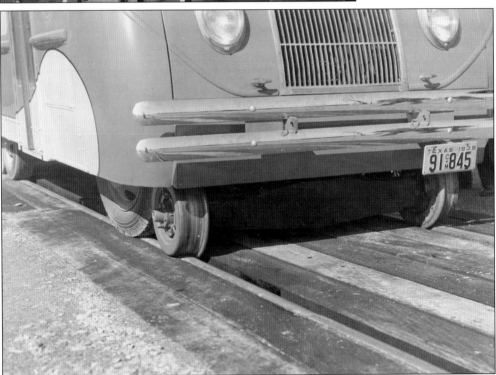

The intention of the Evans Products Company was to create a rail bus that could travel on private railroad right-of-way until it reached a terminal where it would raise is railroad wheels and continue on further over public streets allowing the passengers to complete their trips without transferring. The W&OD Railroad could have taken advantage of this capability to move the line car over public streets more quickly than traveling over the rails to a trouble spot. (Photograph by Evans Products Company.)

Seven
PASSENGER EQUIPMENT

The W&OD Railway electrical passenger equipment consisted of holdovers from the Great Falls & Old Dominion Railroad, new equipment bought from the Southern Car Company of High Point, North Carolina, and used equipment of the J.G. Brill Company of Philadelphia, Pennsylvania, bought from the Arlington & Fairfax Railway. Following the cessation of electric passenger car service on April 1, 1941, the railroad sold or scrapped its cars.

World War II rationing of gas and rubber forced the W&OD Railroad to reenter the passenger business. The railroad scrambled to find equipment; what it found was a two-car, direct-drive, gasoline-powered experimental train set built by the Budd Company for the Pennsylvania Railroad. Budd Company had built the cars as part of its efforts to develop lightweight, stainless-steel passenger cars. In one of many situations unique to the W&OD Railroad, the underpowered Budd cars had to be pushed up the steep 1.25-mile grade out of Rosslyn. Passenger service returned with a daily round-trip between Rosslyn and Leesburg on March 22, 1943, using the Budd cars.

Next, in 1943, the W&OD Railroad purchased two gas-electric cars: No. 45 from the New York Central Railroad and No. 46 from the Gulf, Mobile & Ohio Railroad. Once the gas-electric passenger cars had been purchased, the railroad was able to expand service to three round-trips, with two trips running the full distance to Purcellville. Car No. 45, a 32-seater, proved a good runner and made the last passenger train trip on May 31, 1951, carrying 65 passengers. Car No. 46's engine soon failed, however, and the shop forces decided against replacing the engine. Because passenger equipment was needed to provide for three round-trips a day, Car No. 46 had to be pulled by a diesel-electric freight locomotive, certainly an unusual sight. Car No. 52, built for the New York Central Railroad, was purchased secondhand in 1944, allowing Car No. 46 to be placed on the "back track" in the Rosslyn yard next to Lee Highway to be used in emergencies.

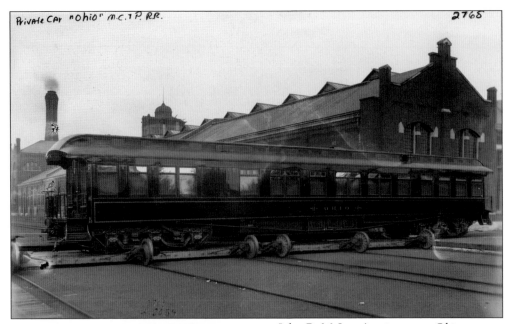

Private Car "Ohio" M.C.T.P. RR. 2765

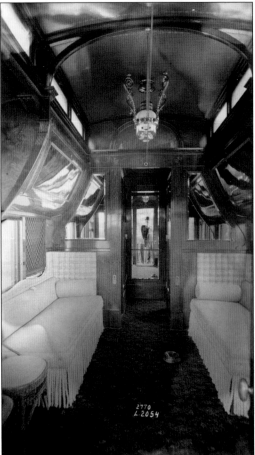

John R. McLean's private car, *Ohio* (seen here), was built by the Pullman Palace Car Company and was ready to be delivered on March 20, 1894. McLean may have traveled over the Bluemont Branch in this car before he leased the line. (Courtesy of Archives Center, National Museum of American History, Smithsonian Institution, Pullman Palace Car Company Photographs.)

The *Ohio*'s sleeping berths are visible above the sofas in the observation room. Looking forward, the mirror on the wall reflects the photographer at work. The public toilet is located on the other side of the wall behind the left sofa, while a trunk room is behind the sofa on the right. (Courtesy of Archives Center, National Museum of American History, Smithsonian Institution, Pullman Palace Car Company Photographs.)

The W&OD Railway ordered four combination passenger-baggage cars from the Southern Car Company of High Point, North Carolina. Two baggage compartments were equipped to handle mail. This photograph of the baggage compartment of Car No.43 was taken on August 10, 1940. (Photograph by John F. Burns Jr.)

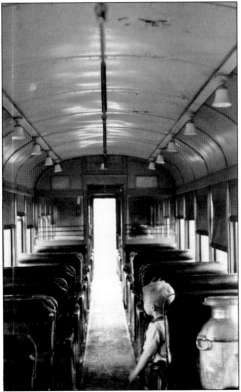

Passengers rode in relative comfort during the summers inside Car No. 76, but its lack of insulation could make for cold rides in the winter. Smokers had their own section at the other end of the car. According to expressman Eugene Bicksler, the train would stop anywhere to pick up a passenger, but "you better get out there and flag it down." (Photograph by John F. Burns Jr.)

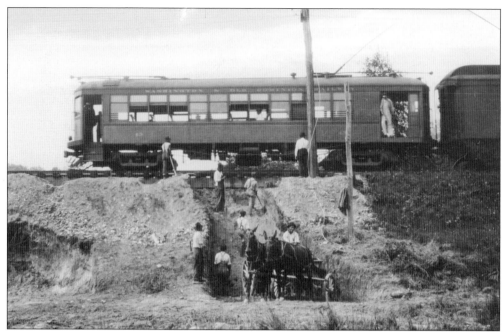

Combine No. 43 gingerly passes over workers clearing soil to make an underpass for Russell Road in Alexandria near Route 1 in 1916. This is a rare photograph showing a W&OD Railway car equipped with two trolley poles at each end for running over the aqueduct bridge to the Washington, DC, station. (Courtesy of National Archives.)

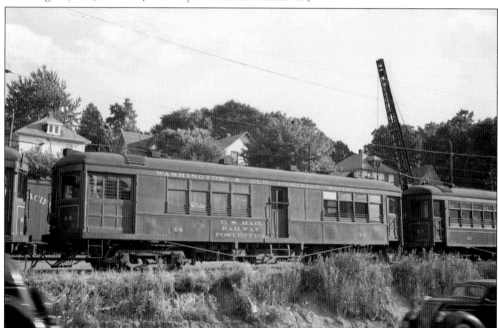

Combine No. 44 began as a simple combine built by the Southern Car Company in 1912. It was rebuilt after a fire in 1922, and, around 1930, had part of the passenger compartment converted into a US mail railway post office, as seen here on August 10, 1940. The expressmen continued to handle express packages from the baggage compartment. (Photograph by John F. Burns Jr.)

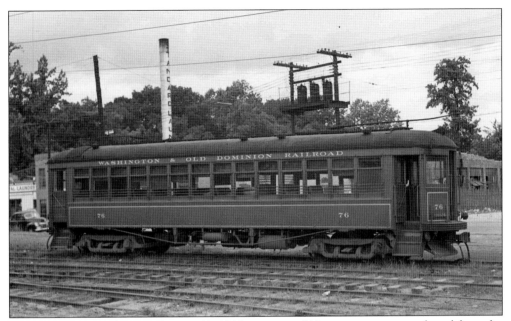

Coach No. 76, seen here on August 10, 1940, was one of 16 passenger cars purchased from the Southern Car Company in 1912 to augment the cars that came from the Great Falls line. The coaches and combination passenger-baggage cars were 50 feet long overall. They made up the backbone of the railroad's fleet of electric passenger cars. (Photograph by John F. Burns Jr.)

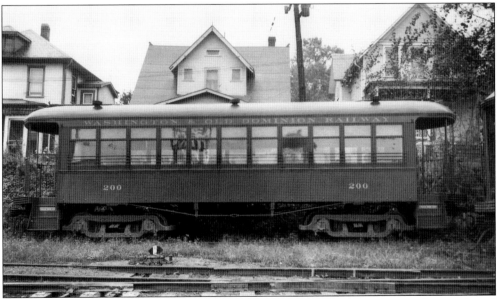

Seen here in Rosslyn on September 14, 1933, Trailer No. 200 was one of six trailers purchased from the Southern Car Company to provide additional seating capacity. *Inside Loudoun: The Way It Was*, by Frances H. Reid, includes a photograph showing Locomotive No. 26 pulling a boxcar and a 200-series trailer on the morning milk train from Purcellville. (Photograph by Howard E. Johnston.)

The engineer was issued operator's tools. The control key was inserted at the top on the left of the tall box and moved to change the car's direction, as seen here in Car No. 43 on August 10, 1940. The speed controller was placed over the stem to the left of the air gauge. The brake handle was placed over the gear to the right. (Photograph by John F. Burns Jr.)

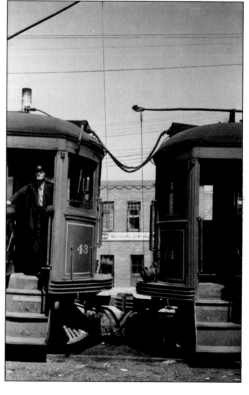

Conductor John W. Kelly stands in the vestibule of Car No. 43 at Rosslyn on September 2, 1940. Southern Car Company cars had radial couplers mounted on a pin and supported with a moving bracket instead of a standard freight-car coupler mounted in a box. Radial couplers allowed the cars to remain joined as they negotiated sharp curves. (Photograph by John F. Burns Jr.)

DAILY EXCEPT SUNDAYS

G. C. BAGGETT Vice-President and General Manager	BETWEEN ROSSLYN AND PURCELLVILLE	J. M. McLANEY Chief Dispatcher

WESTBOUND TRAINS			Miles from Rosslyn	STATIONS	Station Numbers	EASTBOUND TRAINS			Minimum Time bet. Stations Frt. Trains
First Class						First Class			
3	5	1				2	4	8	
P.M. 6.05	P.M. 1.55	A.M. 6.15	.0	Lv. Rosslyn Ar.	1	A.M. 7.40	A.M. 11.05	P.M. 7.24	
				1.5					7
f6.10	f2.01	f6.20	1.5	Thrifton	2	f7.35	f10.59	f7.18	
				3.0					13
f6.23	f2.11	f6.28	4.5	Bluemont Jct.	5	f7.22	f10.50	f7.09	
				2.0					7
f6.28	f2.16	f6.35	6.5	Falls Church	7	s7.17	s10.45	s7.04	
				1.2					4
f6.34	f2.22	f6.39	7.7	West End	8	f7.11	f10.40	f6.59	
				2.1					7
f6.39	f2.28	f6.45	9.8	Dunn Loring	10	f7.06	f10.34	f6.53	
				1.0					3
f6.42	f2.30	f6.47	10.8	Wedderburn	11	f7.02	f10.32	f6.51	
				1.6					5
f6.46[8]	f2.37	f6.56[2]	12.4	Vienna	13	f6.56[1]	f10.27	f6.46[8]	
				2.9					9
f6.54	f2.45	s7.05	15.3	Hunter	16	s6.49	f10.19	f6.39	
				3.1					10
f7.03	f2.55	f7.13	18.4	Sunset Hills	18	f6.40	f10.09	f6.31	
				2.2					7
s7.10	f3.01	f7.20	20.6	Herndon	21	s6.35	s10.03	s6.25	
				3.5					11
f7.19	f3.11	f7.30	24.1	Sterling	25	f6.25	f9.54	f6.13	
				4.0					12
f7.30	s3.22	f7.39	28.1	Ashburn	29	f6.15	f9.42	f6.03	
				2.0					7
f7.35	f3.27	f7.44	30.1	Belmont Park	32	f6.10	f9.37	f5.58	
				4.6					14
7.45	s3.40	s7.58	34.7	Leesburg	35	6.00	s9.27	s5.48	
				3.7					11
P.M.	f3.52	f8.13	38.4	Clarkes Gap	39	A.M.	f9.12	f5.35	
				0.8					3
	f3.55	f8.16	39.2	Paeonian Sps.	40		f9.10	f5.33	
				1.8					6
	f4.00	f8.21	41.0	Hamilton	41		f9.04	f5.28	
				3.6					12
	4.15[8]	8.32[4]	44.6	Purcellville	45		8.55[1]	5.20	
P.M.	P.M.	A.M.		Ar. Lv.		A.M.	A.M.	P.M.	
3	5	1				2	4	8	

Gas-electric service consisted of two trains a day to Purcellville, with an additional train terminating at Leesburg. The train to Leesburg was the last of the day to leave Rosslyn, was tied up overnight in Leesburg, and was the first eastbound train in the morning. In 1948, Douglas Lee became conductor for Trains 1, 4, 5, and 8, working with engineer Victor O. Havener. Trains 2 and 3 were operated by Foster R. Ormsbee and John W. Kelly. The crew of Trains 2 and 3 could either stay overnight in Leesburg or drive back to their homes and return the next morning. Trains 4 and 5 carried the mail and express. (Courtesy of W&OD Railroad.)

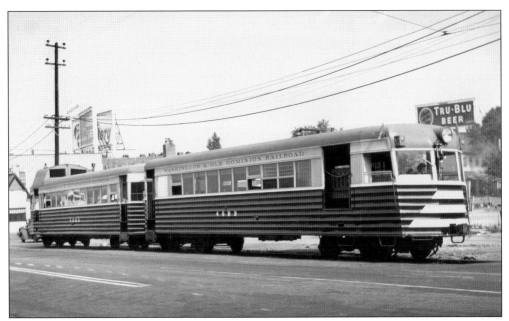

The Budd cars are leaving Rosslyn on July 14, 1943. The set was underpowered, so its journey to Leesburg, uphill most of the way, could take two and a half hours. Traveling back to Rosslyn, however, could take as little as one and a half hours. (Photograph by Edward Tennyson, courtesy of Northern Virginia Regional Park Authority collection.)

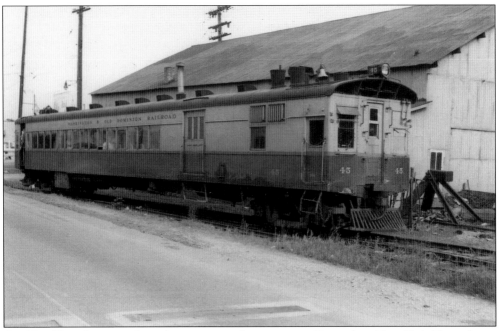

Car No. 45 is almost ready to depart on its afternoon run. Formerly a New York Central gas-electric, it was bought in 1943. Car No. 45 still has its smoking compartment and stands on the north side of the railroad's shop building in Rosslyn, next to Lee Highway. (Photograph by John F. Burns Jr.)

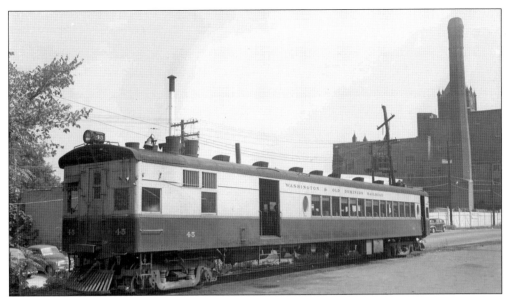

No. 45, an Osgood Bradley combination baggage-passenger car is sitting on the back track at Rosslyn on September 15, 1949. It was originally painted in a black, gray, and white scheme, but the railroad changed the colors to yellow and black, with red trim. The Cherry smash plant stands at the back. (Photograph by Leonard W. Rice.)

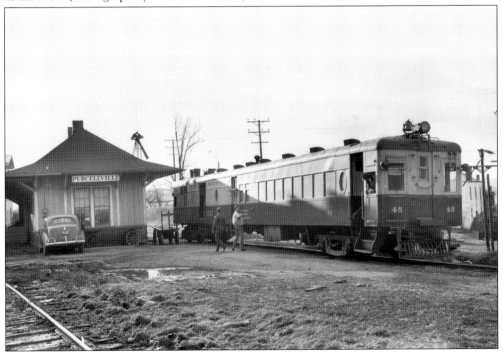

Here, the crew is ready to leave Purcellville in March 1951. At this point, Car No. 45 has been reconfigured into a baggage-mail-passenger combination car. The original baggage compartment was kept, and the smoking compartment was converted into the mail compartment in the fall of 1948. Railway post office equipment was transferred from Car No. 46 into Car No. 45. (Courtesy of Northern Virginia Regional Park Authority collection.)

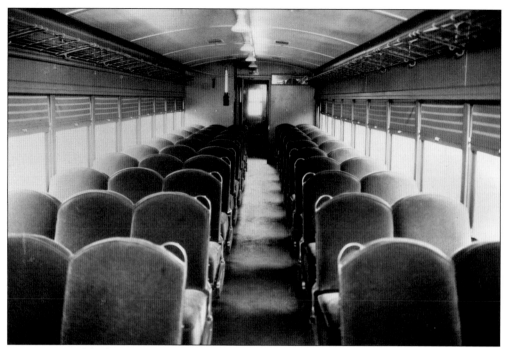

Passengers could ride in relative comfort in cushioned seats in Car No. 45. When it was new, the car could seat 65 passengers. According to Joseph A. Weyraugh, the seats were wool, scratchy, and of a caramel color. (Photograph by Joseph A. Weyraugh, courtesy of Maria Weyraugh.)

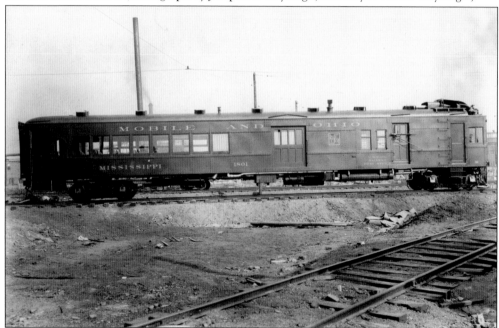

Mobile & Ohio Railroad car No. 1801 was purchased in November 1943 by the W&OD Railroad, where it became Car No. 46. The car is shown at the St. Louis Car Company's plant ready to be delivered. (Courtesy of University Archives, Department of Special Collections, Washington University Libraries, St. Louis, Missouri, St. Louis Car Company Collection.)

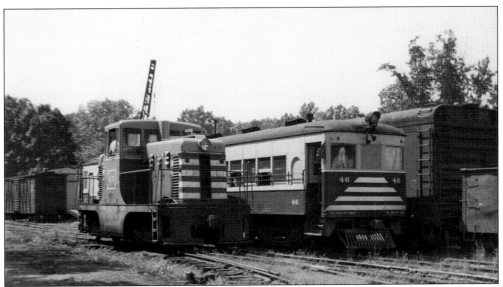

After loading passengers, to get locomotive No. 47 on the outbound end of disabled Car No. 46, the crew would place No. 46 on a downward sloping track, move the locomotive past the eastward facing switch, throw the switch, move the locomotive to the west, rethrow the switch, and allow No. 46 to roll down hill to the east with the help of the passengers' weight, where No. 47 could then couple on to its outbound (west) end. In the photograph above, the conductor operates the brake wheel as No. 46 is just beginning to roll to the east. Below, in August 1946, conductor Dolph N. Cunningham signals the engineer in No. 47 to couple onto No. 46. Reportedly, No. 46 suffered a cracked engine head, rendering the motor irreparable. (Both photographs by Herbert H. Harwood.)

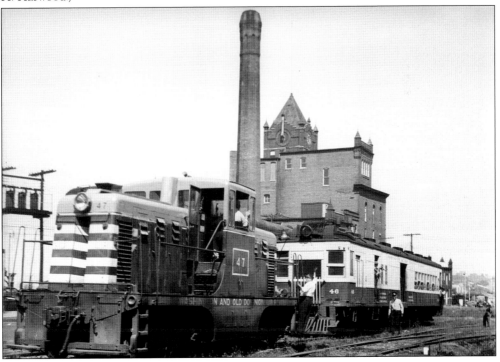

Electro-Motive Corporation and the St. Louis Car Company built Car No. 46 with a 220-horsepower Winton engine, and Car No. 1180 of the Boston & Maine Railroad with a 275-horsepower Winton engine. This image shows the engineer's station in No. 1180. The engine is to the left of the generator, seen at the bottom. (Photograph by the author, courtesy of Museum of Transportation collection, St. Louis County Parks.)

Here, No. 46 sits on the back track in the W&OD Railroad's first paint scheme of black and gray with white trim in 1946. No. 46 has had her passenger-end door closed off and filled in, as evidenced by the wearing paint between the numbers. This car was originally equipped with a train door and diaphragm, as seen on page 104. (Photograph by Herbert H. Harwood Jr.)

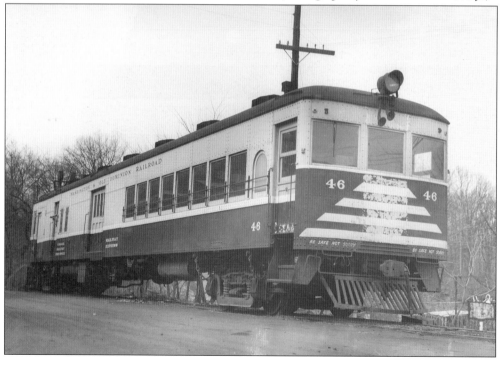

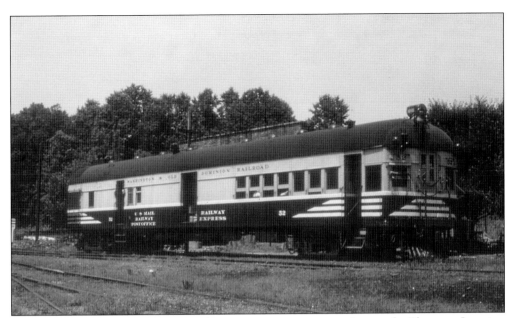

Car No. 52, a J.G. Brill Company gas-electric passenger car, is seen here at the Bluemont Junction on the westbound Rosslyn Branch track on June 28, 1945. While the car had a gasoline engine, it carried a shop mechanic on board to keep it running. It performed quite well once the engine was replaced with a Cummins Inc. diesel engine. (Photograph by Leonard W. Rice.)

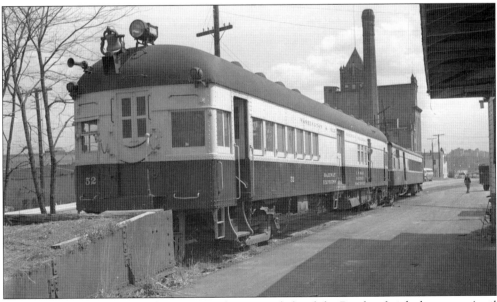

The former New York Central M-403 gas-electric sits behind the Rosslyn freight house on April 12, 1947. W&OD Railroad shop forces finished installing a new Cummins 200-horsepower diesel engine on July 2, 1947. The shop forces had to cut a hole in the side of No. 52 to install the Cummins engine. (Photograph by John F. Burns Jr.)

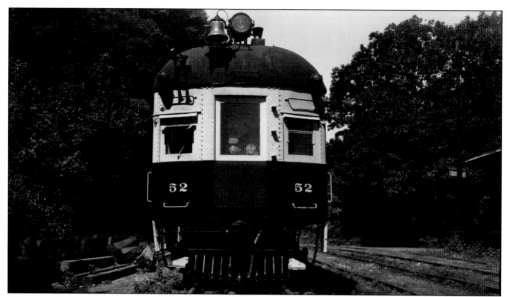

The new Cummins engine was installed on July 2, 1947, when this photograph was taken. Once the engine was installed, the railroad took it for a trial run. The engineer sat right next to the motor, which is visible through the center window. Douglas Lee exclaimed, "Christmas Day in the morning, it was hot." It was also quite noisy. (Photograph by Leonard W. Rice.)

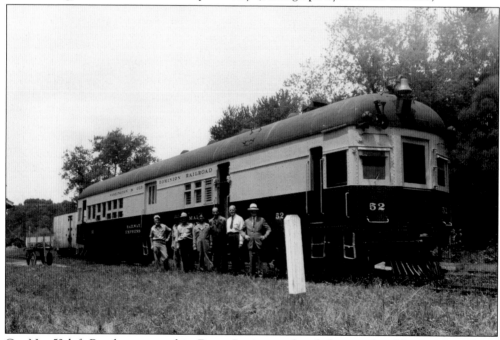

Car No. 52 left Rosslyn, stopped in Dunn Loring, and ended its trial in Vienna. Seen here, from left to right, are Carl Crosen, engineer; Clarence O'Rourke, conductor; Charles O. Bailey, superintendent of motive power; Milton G. Riley or Dewey Duncan, brakeman; Ray Crosen or John King, shop mechanic; Robert M. McNamara, vice president; and George C. Baggett, vice president and general manager. (Photograph by Leonard W. Rice, courtesy of Northern Virginia Regional Park Authority collection.)

Eight
FREIGHT LOCOMOTIVES

According to an Interstate Commerce Commission, Division of Valuation, report in 1917, steam locomotives were serviced at facilities at St. Elmore, or "St. Elmo," in Alexandria, while the electric equipment was serviced in Rosslyn. Steam locomotives were used until the W&OD Railway had completed its electrification process and obtained some electric freight locomotives—by about 1918.

Initially, the railroad leased some locomotives from the Southern Railway before purchasing two Baldwin Locomotive Works steam engines to hold down the freight service while electrification was being completed and electric freight locomotives were being procured. The first electric locomotives were assembled in the railroad's shops from bodies built by the Southern Car Company, electrical equipment built by Westinghouse Electric & Manufacturing Company, and wheel sets built by Standard Car Company.

After a few wrecks, the railroad had spare equipment on hand but still needed more freight power. Workers built the bodies of two new locomotives from old boxcars, and added electrical and running equipment from wrecked passenger cars. Locomotives No. 25 and 26 became the darlings of railfans. Locomotive No. 26 was known as the "Chinese Pagoda" and "Submarine" because of its overall shape and its circular windows. Locomotive No. 25 survived the W&OD Railroad to serve on the Hagerstown & Frederick Railroad in western Maryland.

Freight requirements continued to grow, and the railroad bought two locomotives new from the Baldwin Locomotive Works and Westinghouse Electric and Manufacturing companies. Locomotive No. 50 is a real survivor, still operating today, more than 90 years after it was built.

The railroad bought several new diesel-electric locomotives in the 1940s with cash from the sale of its electric power transmission system. Used and new equipment was bought in the 1950s, after the C&O purchased the W&OD Railroad. For a few years, the railroad leased 1,000-horsepower C&O diesel switcher locomotives to pull trains of sand and gravel for the construction of Dulles International Airport.

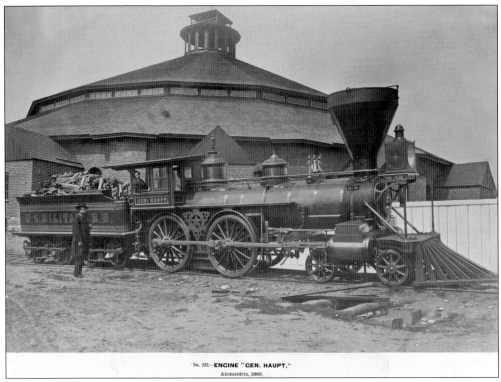

The wood-burning locomotive *Gen'l. Haupt* was typical of the Civil War era and was almost identical to the Alexandria, Loudoun & Hampshire Railroad's *Clarke*. Here, the locomotive sits in front of the roundhouse south of Duke Street in Alexandria in 1863. The William Mason Machine Works of Taunton, Massachusetts, finished the *Gen'l. Haupt* on January 19, 1863. (Courtesy of Library of Congress.)

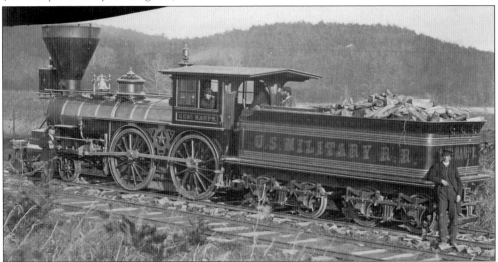

Locomotive technology was in its infancy in 1863—the side rods are flat bars, the drivers lack counter weights, and the crosshead guides (which the fireman is oiling) are missing mechanical lubricators. The rear of this locomotive is seen on page 13. (Courtesy of Massachusetts Commandery, Military Order of the Loyal Legion and the US Army Military History Institute.)

Southern Railway Locomotive No. 921 is seen here at the Baldwin Locomotive Works plant in a typical builder's photograph. While this particular locomotive did not pull trains on the Bluemont Branch, its sister locomotives 920, 923, 924, and 925 did. Steam locomotives were dispatched from Alexandria for use on the Bluemont Branch. (Courtesy of Baldwin Locomotive Works.)

No. 25, the first shop-made electric freight locomotive, is seen here in Rosslyn on August 10, 1940. The short side-door suggests that it was built from an insulated boxcar. Barely visible on the roof is the platform that was used by the wire gang to maintain the overhead system. No. 25 became the Hagerstown & Frederick Railroad's Locomotive No. 9. (Photograph by John F. Burns Jr.)

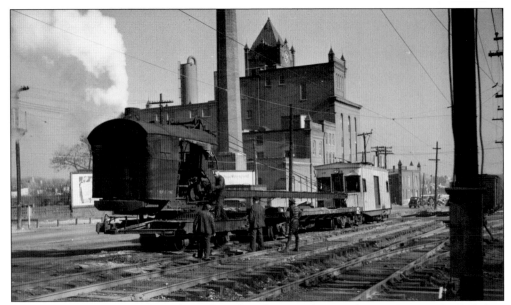

No. 25 had been repainted in white when this photograph was taken on January 3, 1942. It is moving the shop crane with the help of an idler car that allows the locomotive to couple to the crane without contacting the crane boom. The mechanic on the crane might be John King or Carl Crosen. Shop crane No. 175, built in 1906 by Industrial Works, of Bay City, Michigan, had a maximum capacity of 10 tons. (Photograph by John F. Burns Jr.)

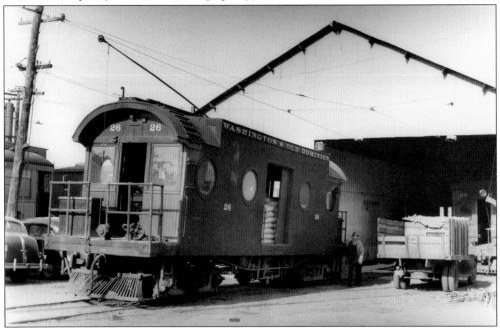

No. 26 was also made in these shops from miscellaneous car parts and an old boxcar. The electrical equipment came from interurban coach No. 14. The odd shape of No. 26 has led some folks to call it a submarine and others a pagoda. Rumors suggest that the mechanic who designed her liked boats. (Photograph by Edward Tennyson, courtesy of Northern Virginia Regional Park Authority collection.)

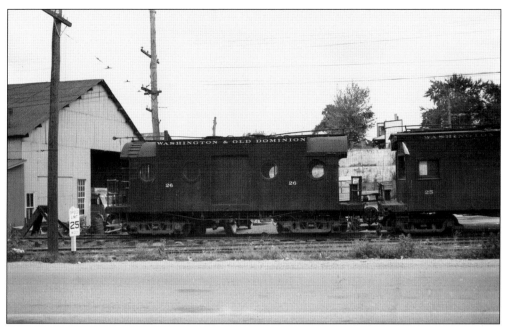

No. 26 was always painted black, as seen here on August 10, 1940. The platforms at each end allowed a crewman to raise and lower the trolley poles to collect the electric power. The smokestack sticking up from the roof above the A in *Washington* served a coal-fired stove that was used to keep the crew warm, particularly when the electricity failed. (Photograph by John F. Burns Jr.)

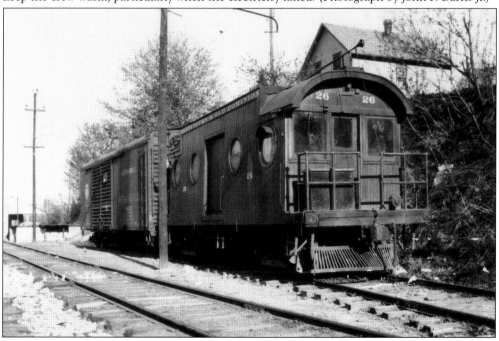

No. 26 is seen here coupled to a Pennsylvania Railroad automobile boxcar on June 30, 1940. The box on the platform held sand to help with traction. The rubber hose under the corner, running through the safety fence and attached to the truck, dropped sand in front of the wheels. The engineer's window dropped down. (Photograph by John F. Burns Jr.)

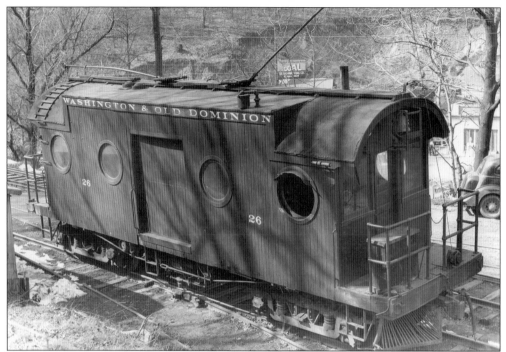

No. 26 is running westbound near the west end of the Rosslyn yard in May 1939. The cylinder attached to the pipes on the roof may have been an air filter for the air-brake system compressor. The air compressor may have stood just behind the engineer and been responsible for the oil stain on the side bottom. (Photograph by Leonard W. Rice, courtesy of Herbert H. Harwood collection.)

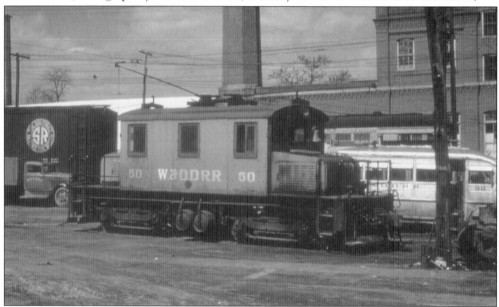

This photograph from March 25, 1944, is one of the last images of Locomotive No. 50 in use on the W&OD Railroad. No. 50 was used to help move freight cars up the hill from Bluemont Junction and up the hill leaving Rosslyn. The locomotive was painted maroon and gray at the suggestion of Joseph A. Weyraugh. (Photograph by Leonard W. Rice.)

A railfan pretends to operate the Class B Baldwin-Westinghouse Locomotive No. 50 on September 20, 2009, where it is still in use on the Iowa Traction Railroad almost 90 years after it was finished, in February 1921. The big black box with the shiny metal arc on it is the master controller. The 16-foot distance between the truck centers allows the locomotive to go around very sharp curves. (Photograph by the author.)

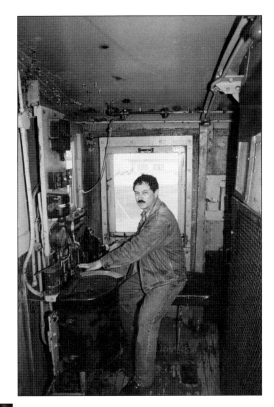

The crew has to work around the caged electric control equipment, which is reminiscent of a manufacturing plant floor. The author stood in the engineer's cab at one end looking down the side of the locomotive at the engineer's controls at the other end on September 20, 2009. (Photograph by the author.)

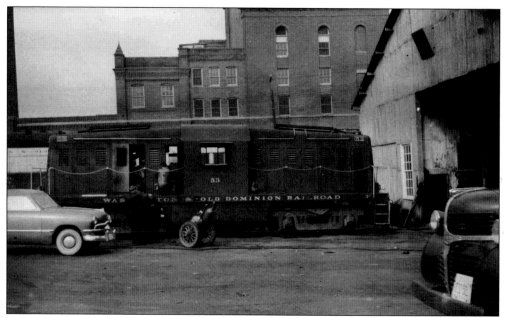

The railroad purchased Whitcomb Diesel No. 53 in 1946 from the US Army. The radiators of each hood's Budda engines faced the engineer's cab, so either the engines got hot or the engineer got hot, because the cab doors had to be kept closed to let the radiators breath through the hood louvers. Douglas Lee once measured the temperature inside the cab at 120 degrees. (Photograph by John F. Burns Jr.)

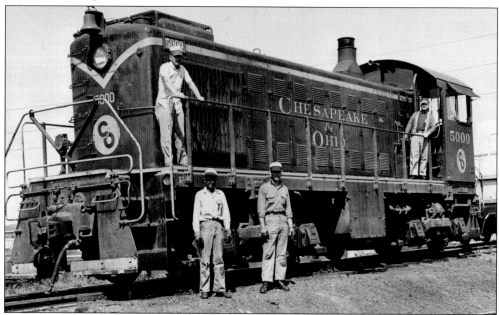

The W&OD Railroad crew poses on the leased C&O American Locomotive Company (ALCO) diesel switcher in the 1960s. Frank Cunningham is on the engine's walkway on the left, and Douglas Lee, the engineer, stands in the cab doorway on the right. Art Cole is standing on the ground on the left next to Randolph Shutts. (Courtesy of Northern Virginia Regional Park Authority collection.)

Nine

MAINTENANCE OF WAY EQUIPMENT

In 1947, Roger Fox told W. Burton Barber, the new superintendent of maintenance of way and structures, that the W&OD Railroad tracks were "two streaks of rust on rotten ties." A 1933 addendum to a tax report of the W&OD Railway pleading for more reasonable property tax rates from the counties notes that all of the rail used to build the tracks to Bluemont and Great Falls was bought secondhand when it was laid the first time. Then, when one side of a railhead wore out, the track gangs removed the rail, turned it end for end, and spiked it back down. Obviously, the track maintenance crews had their work cut out for them.

Before Barber arrived, the railroad had divided track maintenance into seven sections, each section 7.5 miles long, with a single gang of men led by a foreman to maintain it. Section foremen included Frank Shutts, who supervised the Herndon section gang; John Dempsey, who supervised the Vienna section gang; Charles J. Houchins, who covered the Paeonian Springs section; and Roger Fox, who covered the Leesburg section.

Track crews initially consisted of three men and a foreman. Barber revised the organization, changing the section coverage to 14 miles and adding one crew member to each section.

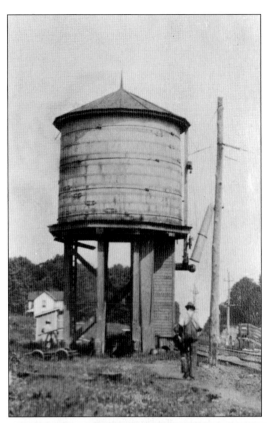

A Sheffield Car Company lever car stands at the base of the tower on May 28, 1918, just west of the Vienna station. Based on information given in Southern Railway Maintenance of Way standard drawings, the handcar could travel at almost four miles per hour when the track gang pumped the lever 20 times per minute. Vienna boys used to dare each other to climb the tower's ladder. (Courtesy of Interstate Commerce Commission.)

This Ford Model T–powered speeder belonged to Roger Fox's Leesburg section gang. The Model T, complete with starting crank, was parked at the Leesburg tool house. The track gang gathered its own parts to put this speeder together to avoid using a lever car. Here, the track gang has pulled the speeder onto a siding on July 6, 1940, to let a passenger train pass. (Photograph by John F. Burns Jr.)

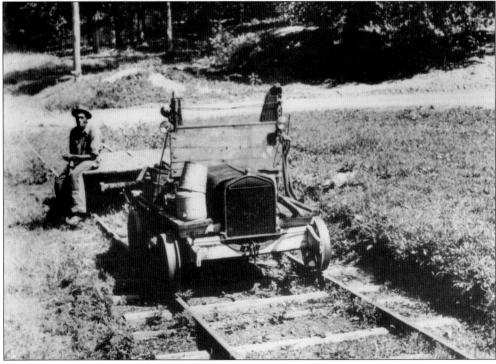

In August 1968, track-work gang trailers were stacked against the lean-to of the Paeonian Springs toolshed on the side away from the photographer. The shed was on the south side of the tracks, a little west of the station's location. The toolshed, without the lean-to, was typical of sheds up and down the railroad. (Photograph by the author.)

Charles J. Houchins's Paeonian Springs track gang scrounged up a Ford Model A to create a gas-powered speeder, the remains of which were found in the lean-to in September 1969. Houchins was the Paeonian Springs track section foreman for almost all of his 41 years on the W&OD Railroad. (Photograph by Thomas A. Coons.)

Steam-shop Crane No. 175 is parked adjacent to the Rosslyn freight house on August 10, 1940 (left), and on March 15, 1941 (right). The operator, John King, was a busy man. He had to fill the water tank, fire up the boiler, keep the boiler steaming while operating the crane, and be on the lookout for live overhead wires. The operator's deck had individual levers with clutches for raising and lowering the boom, raising and lowering the line, and turning the crane from side to side. W. Burton Barber had to replace the crane when it would no longer pick up one end of an empty boxcar. (Left, photograph by John F. Burns Jr.; right, photograph by Leonard W. Rice.)

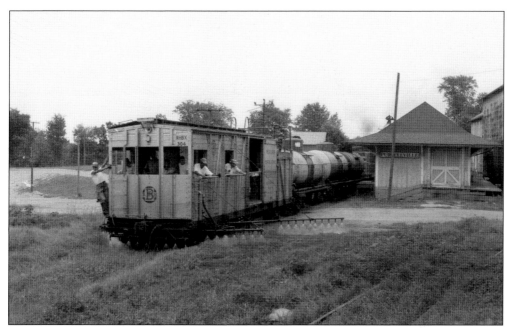

Spraying the weeds down was an annual spring task of the section gangs. Here, the train nears the end of its run from Rosslyn in Purcellville in 1958. (Photograph by David Marcham, courtesy of Northern Virginia Regional Park Authority collection.)

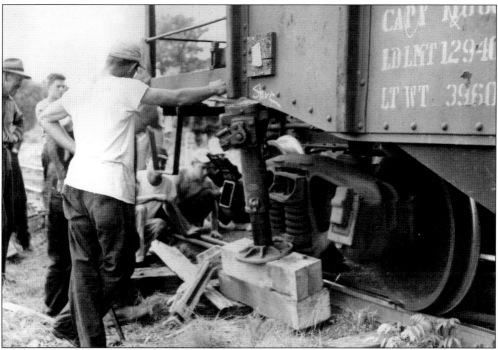

The poor condition of track maintenance because of a lack of funds led to a fair number of derailments. On May 30, 1951, railfans were on board No. 45 when it had to stop for this derailment. No. 55 was working the Shreve Fuel Company siding in East Falls Church when it went on the ground, along with the hopper car. (See bottom of page 56.) (Photograph by John F. Burns Jr.)

Track gangs were responsible for removing snow from the tracks, especially around switches and at station platforms when the railroad was running passenger trains. Here, the crew is busy at Herndon on February 4, 1966. In January–February 1936, Charles J. Houchins's gang spent 30 days keeping drifting snow out of the Scotland Heights cut. (Photograph by Paul Dolkos, courtesy of Northern Virginia Regional Park Authority collection.)

The blizzard of 1966 forced W. Burton Barber to look for snow removal equipment. True to the W&OD Railroad, Barber located a Jordan spreader in the Richmond, Fredericksburg and Potomac Railroad scrapyard. His shop fixed it up so it could clear snow from the line. The Jordan spreader has adjustable blades to keep cuts cleared and fills shaped. (Photograph by W. Burton Barber.)

Ten

SHIPPERS AND RECEIVERS

Freight—from the size of a postcard to a farm tractor and gas-line pipe—provided the income that kept the railroad going. The Alexandria, Loudoun & Hampshire Railroad began to carry mail in 1864. When electric passenger operations ended on April 1, 1941, the railroad continued to operate a railway post office. In another unusual situation, a small diesel-electric freight locomotive was used to pull the de-motored interurban railway post office as a complete mail train. This interurban car was probably used until January 1944, when the gas-electric passenger cars began operating to Purcellville. When the Post Office Department let the last contract expire on May 31, 1951, the railroad ceased all passenger operations. On that day, the railway post office left Rosslyn with 51 sacks of letters.

There were feed and grain mills in every town on the railroad line in Loudoun County. Farmers brought husked corn to be shorn of its leaves and kernels and left with the kernels to feed their cattle. Wheat was sold to the mills for export via the railroad, and the mills imported grains such as rye and barley to mix into feeds to sell to farmers. When the C&O bought the railroad, it intended to build up its traffic by siting new industries on the line. Barber commented that the C&O did not know Fairfax County.

Douglas Lee considered Trap Rock Quarry the only real business on the line. In 1964, according to the Interstate Commerce Commission abandonment case, half of the carloads originated at Trap Rock. Between 15 and 20 carloads of crushed stone were shipped per day during the construction season to Arlington Asphalt, with more customers on top of that. Sometimes, the need for stone was such that train crews were called on Sundays. When the C&O received permission to abandon intrastate shipments, it no longer had to carry crushed stone and was able to reduce its two train crews down to one.

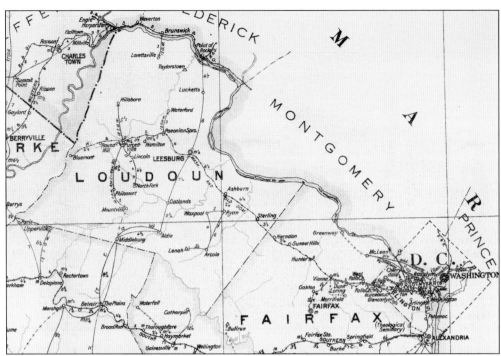

This is a portion of the January 1, 1935, postal route map of Virginia, showing post offices and the distances between them. Post offices are indicated by circles, route beginnings are indicated by double hash lines, and route endings are marked with a single hash line. Lines with dots indicate an electric railroad. Mail service connections are indicated with solid lines. (US Post Office Department map, courtesy of Railway Mail Post Office Society.)

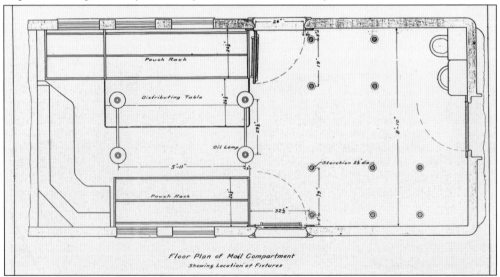

During in the last months of Southern Railway operation—in the summer of 1912—mail and express car No. 201 was used on daily except Sunday trains No. 125 and No. 126 on the Bluemont Branch. This drawing shows the floor plan of its mail compartment and identifies some of the facilities. These same facilities would be present in any railway post office—their numbers would change with the different lengths of mail compartments. (Courtesy of Southern Railway.)

Mail and express trucks are being unloaded into Car No. 44 for the run to Purcellville behind Locomotive No. 48 on June 18, 1943. This scene suggests that Car No. 44 was divided into at least two compartments, one for mail and one for express, and would have carried both an expressman—Norman Bicksler, occasionally relieved by his brother Eugene Bicksler—and railway mail service clerk W. Dunn. (Photograph by Leonard W. Rice.)

Passenger service ended for the first time on April 13, 1941, and was reinstated with the Budd cars on March 22, 1943. Since the Budd cars did not have a mail compartment, Car No. 44 probably continued to serve as a mail car until No. 46 was put in service in January 1944. Here, Locomotive No. 48 is approaching the Vienna station with No. 44 on July 14, 1943. (Photograph by Edward Tennyson, courtesy of Northern Virginia Regional Park Authority collection.)

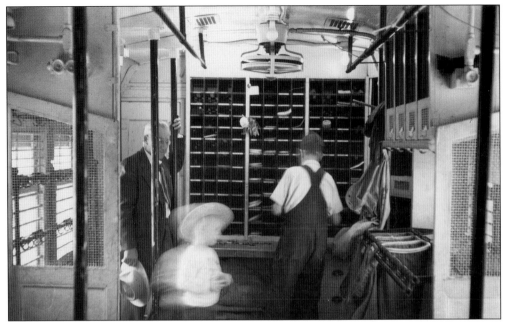

Here, on May 30, 1951, the second-to-last day of the mail contract, railway post office clerk W. Dunn sorts letters for different stations along the line and for communities along the star routes on the route map. The bags on the right may hold mail for different offline destinations such as New York, the Northeast, and the Southeast. (Photograph by John F. Burns Jr.)

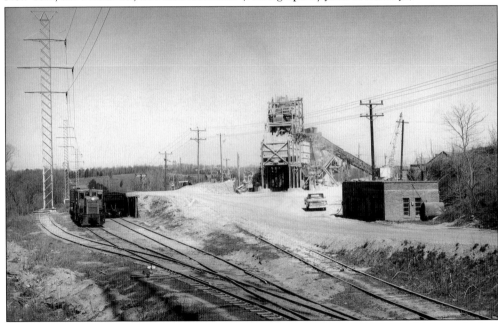

Goose Creek is out of sight behind the locomotive. The trap rock outcrop was discovered when the railroad was building the line about 1858. The quarry extracted the rock and then crushed it in the large structure behind the pickup truck. The railroad then hauled the crushed stone to online customers to create asphalt for roads and cinder blocks for building construction. (Photograph by Herbert H. Harwood.)

126

These two aerial photographs of the Trap Rock quarry were taken on April 30, 1937 (above), and June 2, 1950 (below). Goose Creek is the large gray band running across both images from the lower left center to the top right. Sycolin Creek enters Goose Creek just above the quarry. The image below shows evidence of the postwar building boom—the quarry pit is much larger. During the 1950s and 1960s, the quarry provided up to 50 percent of the carloads moved per year. (Above, courtesy of National Archives, Record Group No. 114; below, courtesy of US Department of Agriculture, ASCS-APFO.)

DISCOVER THOUSANDS OF LOCAL HISTORY BOOKS
FEATURING MILLIONS OF VINTAGE IMAGES

Arcadia Publishing, the leading local history publisher in the United States, is committed to making history accessible and meaningful through publishing books that celebrate and preserve the heritage of America's people and places.

Find more books like this at
www.arcadiapublishing.com

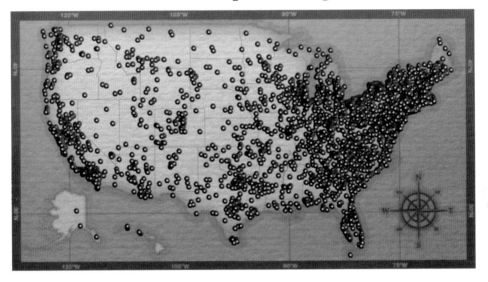

Search for your hometown history, your old stomping grounds, and even your favorite sports team.

Consistent with our mission to preserve history on a local level, this book was printed in South Carolina on American-made paper and manufactured entirely in the United States. Products carrying the accredited Forest Stewardship Council (FSC) label are printed on 100 percent FSC-certified paper.

MADE IN THE
USA